Northern Lights

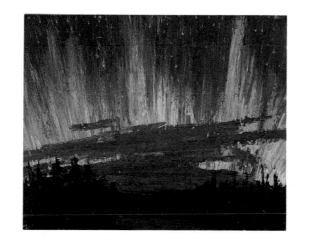

NORTHERN LIGHTS

Masterpieces of Tom Thomson and the Group of Seven

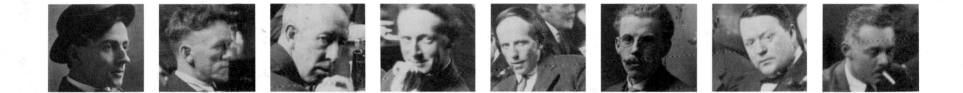

JOAN MURRAY

KEY PORTER BOOKS

Page one: Tom Thomson, *Northern Lights*, 1916?, Montreal Museum of Fine Arts

Page two: J.E.H. MacDonald, *Young Canada*, 1922, The Robert McLaughlin Gallery

The publisher gratefully acknowledges the assistance of the Canada Council and the Ontario Arts Council.

CANADIAN CATALOGUING IN PUBLICATION DATA

Murray, Joan

Northern lights : masterpieces of Tom Thomson and the Group of Seven

ISBN 1-55013-593-7

1. Thomson, Tom, 1877-1917. 2. Group of Seven
(Group of artists).* I. Title.

ND249.T5M88 1994 759.11 C94-931454-4

Key Porter Books Limited
70 The Esplanade, Toronto, Ontario, Canada M5E 1R2

Book design by Scott Richardson
Typeset in Perpetua and electronically assembled by MacTrix DTP
Printed and bound in Canada

94 95 96 97 98 6 5 4 3 2 1

CONTENTS

PREFACE AND ACKNOWLEDGEMENTS

I n 1983 I wrote a little book, *The Best of the Group of Seven*, containing fifty-three colour reproductions of paintings by Tom Thomson and the Group of Seven. In the years which followed, I continued to search for what was the best among the works of the Group. The great benefactor of the gallery I direct, Isabel McLaughlin, steadily adds to our Group of Seven collection, and in 1991 Miriam Fox Squires gave us a splendid A.Y. Jackson (see Pl. 113). The taste and generosity of these donors has enhanced our collection and at the same time helped me to better appreciate why every Canadian gallery of stature needs works by the Group of Seven in their collections. Each gallery uses the Group's works differently, of course. In our gallery, for instance, which is dedicated to twentieth-century Canadian modernism, they help to foster the continued debate about the art of the past, present, and future. In the Art Gallery of Nova Scotia, they provide an example of the native school when compared with the work of seventeenth-century painters such as Dominic Serres. In the McMichael Canadian Art Collection, they are the heart of the collection.

I selected the paintings reproduced in this volume as though the book were an exhibition catalogue: they serve as an invitation to spend some time strolling among these works of art. Since most of the paintings reproduced here are from public collections, I sincerely hope that readers will eventually find their way to the originals.

I'm grateful, for their help with this project, to Greg Spurgeon, Judy Dietz, Sandy Cook, and Elaine Tolmatch, the registrars of, respectively, the National Gallery of Canada, the Art Gallery of Nova Scotia, the McMichael Canadian Art Collection, and the Montreal Museum of Fine Arts. Judy Schwartz assisted with the works at Hart House. Christopher Varley kindly offered suggestions about entries on his grandfather.

Joan Murray
Director, The Robert McLaughlin Gallery, Oshawa

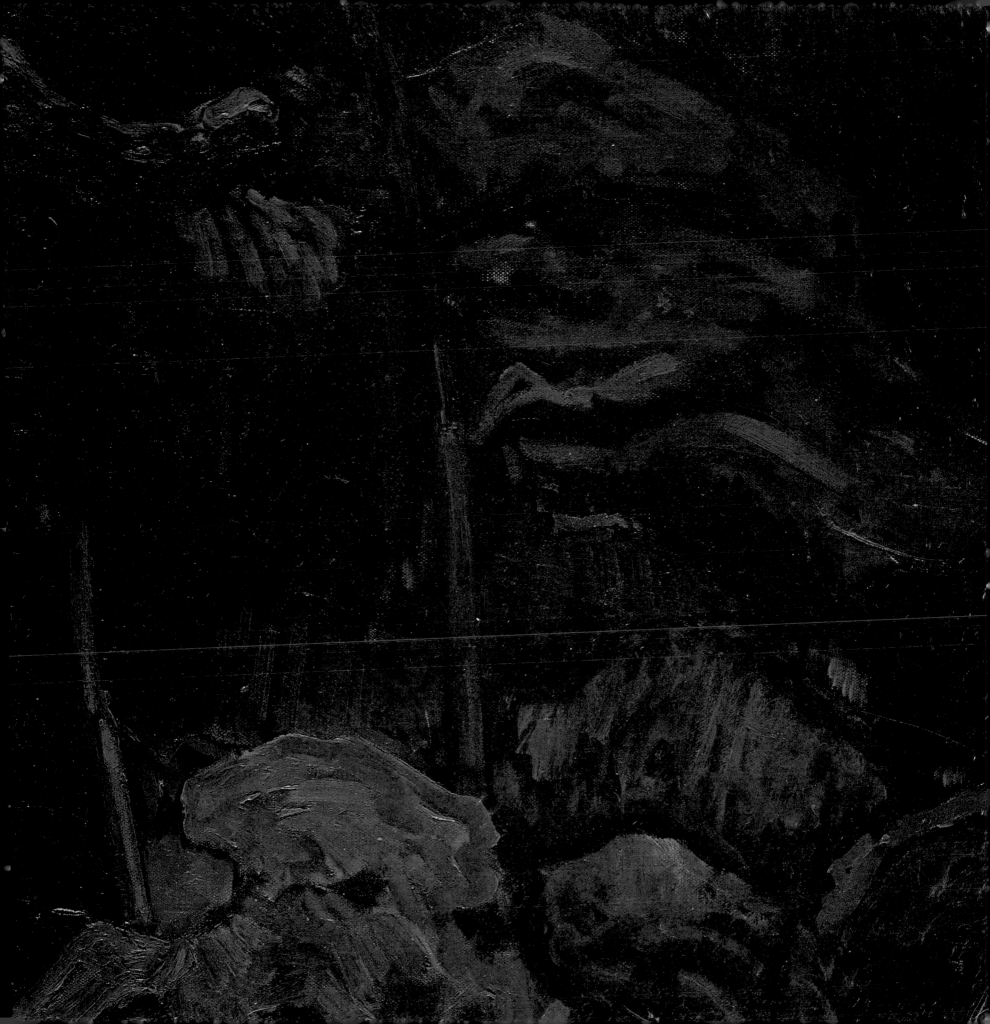

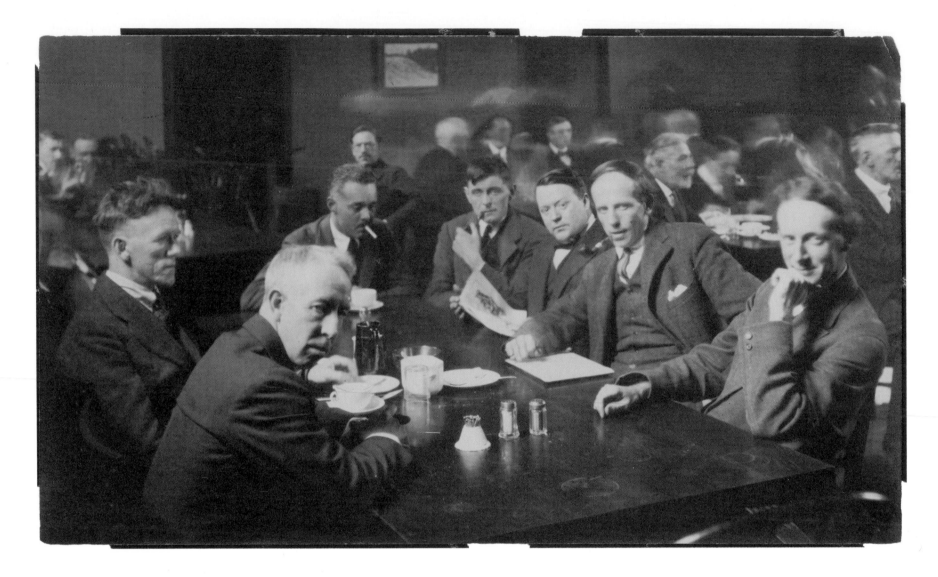

FIGURE 1 *The Group of Seven seated around a table at the Arts and Letters Club, Toronto, c. 1920. From left to right: Varley, Jackson, Harris, Barker Fairley (non-member), Johnston, Lismer, MacDonald (Carmichael is absent).*

The Group of Seven liked to meet for the day in an arts club in Toronto with a totally male membership. The photograph is revealing. Harris (at the head of the table) was the real figure of authority, balanced by MacDonald and Jackson at the two ends. Varley, lost in thought, was a little outside the group. Johnston seems to hold a sketch. Fairley, seated beside Harris, was a professor of modern languages at the University of Toronto. He was supposed to write the foreword to the catalogue for the first show, but before he could do so, he left for Europe. It was Harris who wrote the statement which appeared in the pamphlet, and in several which followed.

PREVIOUS PAGES: *J.E.H. MacDonald,* Algoma Waterfall *(detail), 1920.*

he Group of Seven: if we were art thieves, they are the ones whose work we would want to steal; if we were rich, they are the ones whose work we would want to own. "Let's go in the family room across the hall and off the kitchen. That's where I spend most of my time with Tom and Emily and the TV," a rich collector says to a policeman in W.O. Mitchell's novel, *For Art's Sake*. We know at once that he's referring to Tom Thomson and Emily Carr, and readers mentally agree: we'd like them in our family room too. Of course, they're not members of the Group of Seven, but in our imagination they were almost members – he with his influence on them; she influenced by them. Canadian historian Donald Creighton featured the Group of Seven in *Takeover*, his novel about the distillery business in Toronto. Their work, he said, adorned the walls of the head office of the family firm. Creighton was writing in 1978; however, almost two decades later, Group of Seven mania has swept the country, and in 1995, the seventy-fifth anniversary of the Group's founding, their work is more in demand than ever – even to the point of theft.

It's hard to comprehend that the Group of Seven was founded three-quarters of a century ago; they seem so recent (A.Y. Jackson died in 1974, A.J. Casson in 1992). The echo of their thoughts and point of view is still with us, their paintings displayed in galleries across the country.

Although their artistic ideals had begun to coalesce a decade earlier, it was in 1920 that they decided to formally call themselves a group. Their first exhibition together, which prompted their choice of a name, signalled that they were ready for their shared aesthetic to take its place on the national stage. The young artists in the show (see Fig. 1) became the catalyst for a long revolution in Canadian art. They were our first modern painting group, although it's hard to see the modernism for the trees, which are such a common subject in their work.

Today the artists of that movement – especially Tom Thomson, who died before the Group was formed – are nationally beloved. Their paintings depict, with optimism and vigour, a land of bold effects, powerful weather conditions, and northern vastness. Yet the complex aesthetic concerns addressed by these artists are no less powerful than the northern landscape that was their theme. In 1926, Fred Housser, a friend of Lawren Harris, documented the ideals of the Group in his book, *A Canadian Art Movement*. Group work had to contain a direct reaction to nature, and a native flavour (as A.Y. Jackson said of J.E.H. MacDonald's works).[1] It had to have strength, wrote MacDonald, and

follow faithfully all the seasons, with a broad, rich treatment.[2] Its forms were to be architectural and massive.[3] It was an intensification of the subject, said MacDonald's son, Thoreau MacDonald, full of the power of Canada.[4] The key ideas were grandeur and beauty, a sense of the sublime, vastness, majesty, dignity, austerity, and simplicity.[5] Jackson suggested that the novice painter use a restricted palette consisting of flake white, vermilion, rose madder, a darker madder for the darker reds, chrome orange, chrome yellow, yellow ochre, viridian green, permanent blue, cerulean blue, and lampblack – the rest to come through mixing.[6] Handling was to be powerful and brisk. "Don't niggle," Jackson told one student.[7] MacDonald told others, "Think big, be generous, don't fiddle, enlarge yourselves."[8]

Instead of painting the figure in the tranquil countryside, the Group of Seven chose subjects which revealed a love of the country's natural environment, and especially Canada's Northland. At first they painted what was called Ontario's hinterland, then they moved farther afield.[9] It was a simple subject, but one which held a strong attraction for these painters. Housser wrote that "this North is a magnetic land, able to get hold of men and draw them as it draws the steel of the compass."[10] The feeling of a divine presence could be experienced in or through nature, as Housser indicated when he wrote, "The tang of the North is colouring souls as it colours the leaves in autumn."[11] The belief that Canada's Northland could reveal its special character was part of a Canada First movement, to which the Group of Seven, and particularly Lawren Harris, contributed. Rudyard Kipling had called Canada the "Lady of the Snows," and his words struck home with Tom Thomson and members of the Group, who often painted snow, finding in it the colours of a prism. "There is so very much in whiteness," Harris said.[12]

In selecting their subject these painters reflected the culture of their period. The future members of the Group of Seven were drawn first to Algonquin Park (indeed, one of the names they had considered adopting for themselves, and occasionally even used, was The Algonquin School), then a relatively new and much-discussed tourist attraction: the more than 5000 square kilometres of wilderness forest, lake, and river had been set aside in 1893 as a conservation area. The park was wilderness which had to be protected, and the record of it became sacred, the material for a collective myth. That myth would in turn help to direct Canadian society's spiritual, and even political, engagement with nature. In capturing the spirit of Algonquin, the Group of Seven opened a new chapter in the growth of Canadian political self-consciousness. They paved the way to a consciousness of the national environment: they were "environmentalists" who did not know the word, pioneers in the ecological movement, aware of the danger to the natural world. As Housser said: "The wilderness is being reclaimed and the forest is making its last stand. . . . But in these Northern Ontario canvases is a spirit which as time advances will be capitalized in literature . . . while these pictures live we can never forget our cradle-environment."[13]

Thomson in particular had a deep-seated reverence for the natural world, having grown up among naturalists. His

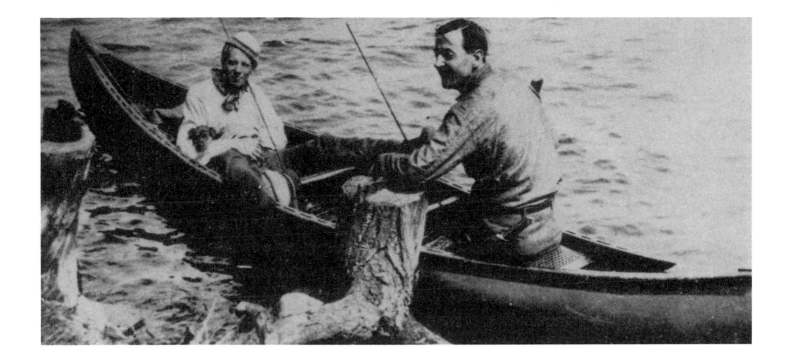

FIGURE 2 *Tom Thomson and Arthur Lismer in a canoe on Smoke Lake, Algonquin Park, 1914.*

grand-uncle, Dr. William Brodie, had argued for the establishment of our national park system and helped create Algonquin Park. A.Y. Jackson's brother Harry was another all-round naturalist (see Fig. 3). It is little wonder that the work of the Group so fully conveyed an awareness of the intrinsic value of the Canadian landscape (see Figs. 4-6).

In matters of style the Group called on a wide variety of sources. The backgrounds of many of the members lay in commercial art, and they applied its structural lessons to their paintings. They looked to British artists, particularly Constable, and later, the artists associated with the Bloomsbury Group. As well, they adapted Post-Impressionism's bold way of applying paint to canvas: Van Gogh was MacDonald's idol, as his students knew.[14] Yet MacDonald seemed to echo Van Gogh's work as though he'd heard about it from another artist, not seen it on gallery walls. His sunflowers are so different from Van Gogh's as to constitute another species. What he did take (and passed on to Thomson) were Van Gogh's bold contour lines to render forms, and the use of contrasting colours, particularly green and red, which Van Gogh had learned about from reading the writings of Eugène Chevreul, the optical chemist.

These were revolutionary matters for Canadian art. The desire naturally followed to show the work. The society exhibitions, such as those mounted by the Royal Canadian Academy and the Ontario Society of Artists, were dominated by conservative attitudes. Impatient with established tradition, the Group decided to organize their own exhibition.

Initially, selecting a name that would precisely describe such a diverse membership – Franklin Carmichael, Lawren Harris, A.Y. Jackson, Frank H. (Franz) Johnston, Arthur Lismer, J.E.H. MacDonald, and F.H. Varley – proved impossible. However, after some discussion they decided that a number was suitably neutral. Through the influence of Lawren Harris they arranged to show their work at the (then) Art Gallery of Toronto, one of the two main galleries in Canada (the other was the National Gallery of Canada). In a sense, the exhibition established them as a new power in art. Whatever adverse criticism followed, especially from the pen of critics such as Hector Charlesworth, the conservative journalist at *Saturday Night*, could not halt the powerful polemic which flowed from their own pens. J.E.H. MacDonald, Lawren Harris, A.Y. Jackson, and their friends, such as Housser, were able writers. Their stated aim was "art takes to the road," as Housser said.[15] They covered Canada as though on snowshoes or skis, and soon their art took a broader road, in a series of exhibitions culminating in 1924 with their participation in the British Empire Exhibition at Wembley, England.

At the beginning of the 1920s, criticism of the Group's work focused primarily on the use of colour and effect. Members sketched outdoors and used the sketches to create works in the studio, introducing compositional balance or strengthening details. Yet the paintings emphasized colour, light, and pattern, underscoring the Group's freedom from the more meticulous, atmospheric handling that characterized earlier works.

Elements of the Group's style had originally been developed by Tom Thomson by 1915. In works such as *Northern River* (Pl. 21), he had expressed the ethos the Group would make its own: a feeling for the sublime mystery of the Canadian landscape. In his book, Housser recounted the steps by which the Group came to know itself – their awareness of one another, about 1910; their first view, about 1912, of Thomson's meticulous sketches done up north; 1913, when MacDonald and Harris saw the exhibition of modern Scandinavian art at Buffalo's Albright Art Gallery. Slowly the group took form. A key figure in the process was Dr. J.M. MacCallum, an ophthalmologist who loved the outdoors. He invited Thomson and members of the Group to his summer cottage on Georgian Bay. And then there was a place to work: the Studio Building in Toronto, put up by Harris and MacCallum in 1913, provided a centre.

By 1915 the style was coalescing around a central subject – the "outdoors." Carmichael, working outdoors in sub-zero cold, found the composition of a painting "went together to suit him."[16] The same discovery was being made by them all. The choice of imagery radiated ethical imperatives. The placement of the painter (and viewers in the imagination) projected older ideals of simplicity and a healthy, chaste, masculine life. Moreover, the Group did not try to instruct, only to persuade. Many in their audience found their work a model object lesson that evoked immediate emotional response. With the choice of an outdoors subject came a certain spiritual quality, and mental associations of peace, strength, and high, boundless aspirations. The images touched a common nerve, calling on some collective memory-fantasy vaguely associated with the spiritual. The landscape contained no biblical references, but it was religion

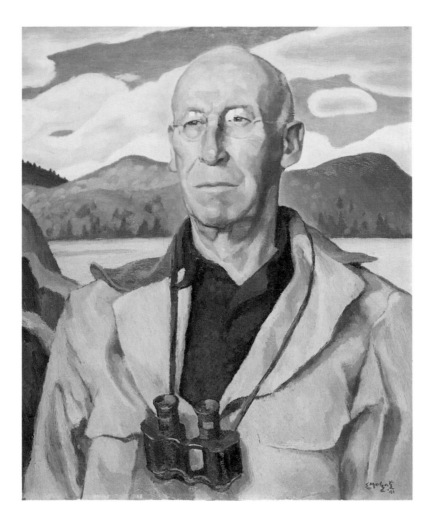

FIGURE 3

EDWIN HOLGATE

The Naturalist, 1941

Oil on canvas
64.7 x 54.5 cm (25½ x 21⁷⁄₁₆ in)
Musée du Québec, Québec

A strain of nature-love runs through the works of the Group of Seven. Occasionally its antecedents crop up in family members who were naturalists. This portrait by Holgate of Harry Jackson (1877-1961), A.Y.'s elder brother, indicates his hobby: he was a naturalist particularly interested in botany. He was also a keen fisherman. In 1977 his watercolours of mushrooms were shown at the National Gallery of Canada. The book which accompanied the exhibition, edited by Mimi Cazort, published entries from his notebook. They suggest that he was concerned about the environment.

FIGURE 4

A. J. CASSON

Marsh Marigold, early 1920s?

Graphite on paper

27.4 x 20.3 cm (10¾ x 8 in)

McMichael Canadian Art Collection, Kleinburg

Gift of the artist, 1981

FIGURE 5

ARTHUR LISMER

White Pines, Georgian Bay, n.d.

Ink on paper

33.8 x 30.4 cm (13¼ x 12 in)

McMichael Canadian Art Collection, Kleinburg

Gift of the founders, Robert and Signe McMichael, 1987

all the same, a kind of pantheism, and the audience sensed it. MacDonald's waterfalls in particular, which flow toward the foreground from distant hills, recalled the imagery of the River of Life well known from American nineteenth-century painting: a path through life from the cradle to the grave (see Fig. 7). Similar landscape imagery had been used in commissions by the Tiffany Studios for stained-glass windows in churches around 1900 (sometimes with passages from the Scripture added to support the images – "He showed me a pure river of water of life, clear as crystal, proceeding out of the throne of God and of the Lamb").[17] MacDonald, who was a first-class designer and who, in 1903, had worked in London in one of the top design houses of the day, the Carlton Studios, as well as in many important commercial-art firms in Toronto, would have been very familiar with the work of the Tiffany Studios.

The idea that the members of the Group were pioneers, striking out boldly for the road, also has a source in their common religious background. These were men who described themselves as making a Pilgrim's Progress (we think here of John Bunyan) from the world of the Philistines to the mountains of High Art, where Cézanne and others like him lived, and where every modernist wished to go. The images in their paintings – pathways and mountains – reflected the idea. Pictures of their studios or of the artists at work also stress their energy, showing them as vigorous and hard-working (see Figs. 8-10).

FIGURE 6

ARTHUR LISMER

Jack Pine, n.d.

Charcoal on paper

35.9 x 30.2 cm (14½ x 11⅞ in)

Art Gallery of Nova Scotia, Halifax

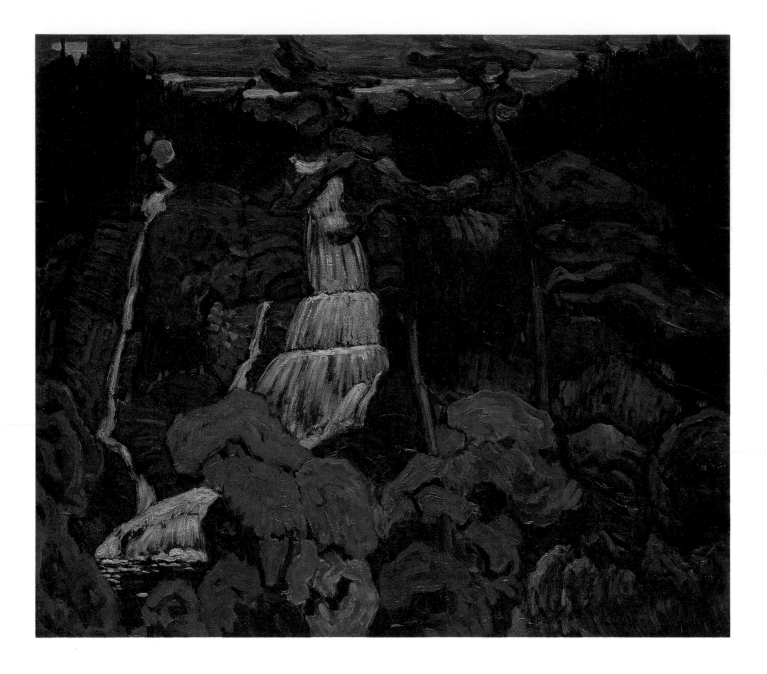

FIGURE 7

J. E. H. MacDONALD

Algoma Waterfall, 1920

Oil on canvas
76.3 x 88.5 cm (30 x 35 in)
McMichael Canadian Art Collection, Kleinburg
Gift of Colonel R.S. McLaughlin, 1968

This shared vision might have led to a formal association before 1920 had the First World War not intervened and scattered them: Jackson to France, Harris to army training at Camp Borden in Ontario, Lismer to Halifax as principal of the School of Art and to work at the Canadian War Records Office (see Fig. 11). Once they did become a group, what they shared lasted for some only briefly. Despite the unanimity they felt toward their "subject," they did not all feel permanently at home with the style once it developed. Works by Johnston, after 1922, for example, are more atmospheric and look different from those by Harris and MacDonald. Membership in the group was flexible, and its exhibitions varied as different painters showed with the group. Through the years three new members were added: A.J. Casson, Edwin Holgate, and L.L. FitzGerald. Other spirited newcomers, such as Lowrie Warrener, showed with the Group. Catalogues of successive shows indicate a change in rhetoric, from a glorification of Canada's natural environment to encouragement of experimentation. The imagery of some of the painters, especially invited exhibitors, adjusted accordingly.

In a few years, Group members were transformed from pioneers to leaders of the Establishment. From 1926, Varley directed the department of painting and drawing at the Vancouver School of Art. In 1927, Lismer supervised the education department at the (then) Art Gallery of Toronto. In 1928, MacDonald became principal of the Ontario College of Art in Toronto. These appointments were the capping sign of their changed status. Bertram Brooker, one of the new young talents of the day, felt that their work had become codified at this time. It showed signs of hardening into a formula, he said; yet, it was only eight years since their first show.[18] By 1930, the original members were beginning to attain a degree of popular success, and group exhibitions were no longer necessary. Although the 1931 show was the last Group exhibition, the Group did not disband. It had shown in 1931, by invitation, the work of twenty-four other painters, including artists from Montreal, Ottawa, and Vancouver. They then asked the more talented of these contributors to join them in forming a new national organization, the Canadian Group of Painters. Nevertheless, the Group of Seven epithet stuck to the original group, especially its more famous members.

The Canadian Group of Painters opened its membership to "freer forms of expression," as Arthur Lismer, one of its presidents, wrote.[19] The influence of the Group was a common thread joining the members of the Canadian Group, but this link was gradually severed on the way to a personal style.

The achievement of the Group of Seven is put in focus by what Arthur Lismer said about Jackson's *The Edge of the Maple Wood*: "It created a feeling of settlement and permanency about a land of which my first impressions were impermanent and transient."[20] In the same way, the work of the Group helped to create our idea of Canada. We understand more about our country when we see it translated by their paintings; their work makes us realize the importance of harnessing our energy to preserve the land. It has acted, as the Group of Seven said they hoped it would (in the foreword to the catalogue of their 1921 exhibition), as "a real civilising factor in the national life."[21]

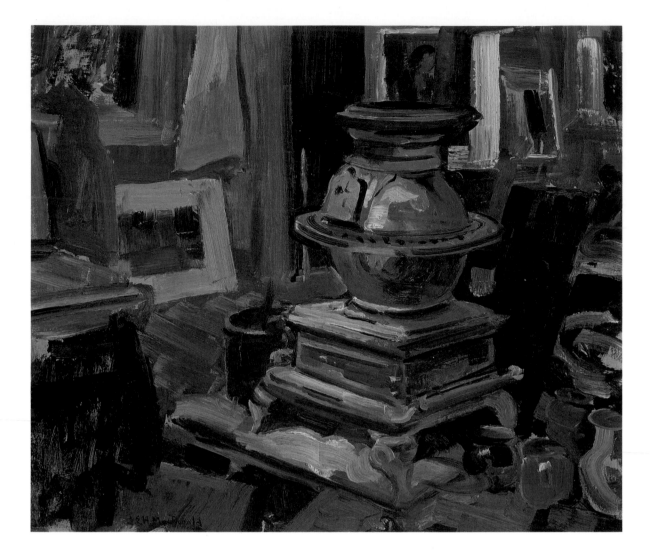

FIGURE 8

J. E. H. MACDONALD

Artist's Studio, 1931

Oil on canvas
44.5 x 52.5 cm (17½ x 20½ in)
Ken Thomson, Toronto

FIGURE 8: *Behind the pot-bellied stove in MacDonald's painting is a bucket for brushes. Note the old frames leaning against the wall.*
FIGURE 9 (right): *Lismer's self-portrait is filled with his own exuberant nervous energy: he shows himself at work but with typical humour. Note his wispy, fly-away hair, a characteristic his students often recall; the apple placed on what looks like the edge of a still life which he is in the act of sketching; and the matches he threw on the floor after lighting his pipe.*

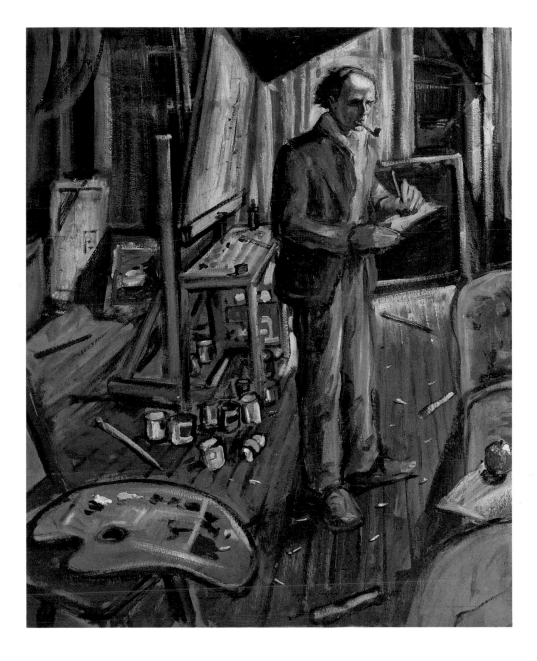

FIGURE 9

ARTHUR LISMER

Self-Portrait, 1924

Oil on canvas

91.0 x 76.3 cm (35⅞ x 30 in)

McMichael Canadian Art Collection, Kleinburg

Gift of A.J. Latner, 1971

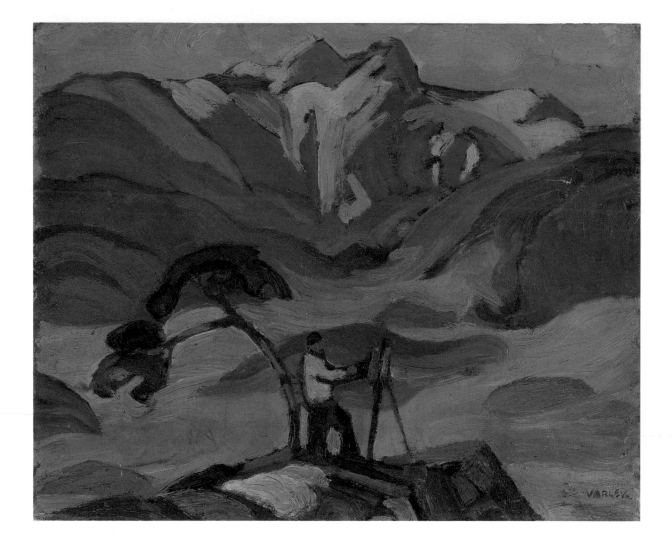

FIGURE 10

F. H. VARLEY

Mountain Sketching, c. 1929

Oil on panel
30.5 x 38.1 cm (12 x 15 in)
Art Gallery of Ontario, Toronto
Gift of Doris Huestis Mills Speirs, Pickering, Ontario, 1971

Varley painted himself "at work" in this mock-heroic mountain scene. His pose with easel on a mountain top is a fabrication; the tree at his back recalls a favourite Thomson motif, but he looks elsewhere, not at it. The Group's apologist, Fred Housser, applied the term "mountain climbers" to the Group. Varley makes gentle fun of the idea here.

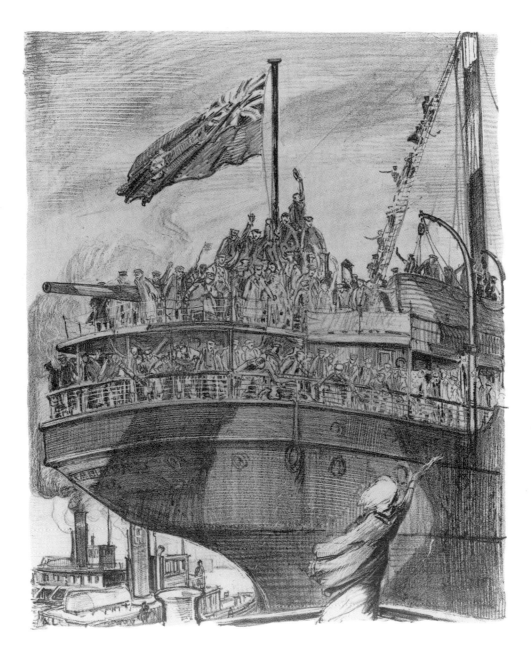

FIGURE 11

ARTHUR LISMER

The Departure of a Transport for Overseas, 1917-18

Lithograph

55.9 x 45.4 cm (20 x 18 in)

Art Gallery of Nova Scotia, Halifax

NOTES

1. Quoted in F.B. Housser, *A Canadian Art Movement: The Story of the Group of Seven* (Toronto: The Macmillan Company of Canada Limited, 1926), 77.

2. Ibid, 143. Housser quoted from an article by MacDonald in the Canadian magazine *Spectator*, as Paul Duval points out in *The Tangled Garden* (Scarborough: Cerebrus Publishing Company Limited, 1978), 94. (Housser thought it was the English *New Statesman*.)

3. Ibid, 145.

4. Thoreau MacDonald, *The Group of Seven* (Toronto: The Ryerson Press, 1944), 15.

5. Ibid, 13, 18; Arthur Lismer, 1950 radio talk quoted in Marjorie Lismer Bridges, *A Border of Beauty* (Toronto: Red Rock, 1977), 128.

6. Interview with Doris Speirs by Paul Bennett, August 4, 1971, unpaginated. Joan Murray's Artists' Files, The Robert McLaughlin Gallery, Oshawa.

7. Ibid.

8. Carl Schaefer recalled MacDonald's advice, quoted by Duval in *The Tangled Garden*, 139.

9. Housser, 17.

10. Ibid, 14.

11. Ibid, 49.

12. Ibid, 36.

13. Ibid, 156.

14. Lowrie Warrener letter to Carl Schaefer, December 9, 1924, Carl Schaefer Papers, National Archives of Canada, Ottawa, MG 30, D-171.

15. Housser, 147.

16. Megan Bice, *Light & Shadow: The Work of Franklin Carmichael* (exhibition catalogue) (Kleinburg: McMichael Canadian Art Collection, 1990), 18.

17. Alastair Duncan, Martin Eidelberg, and Neil Harris, *Masterworks of Louis Comfort Tiffany* (New York: Harry N. Abrams Inc., 1989), 131. MacDonald may even have read or heard about the fierce controversy among the congregation aroused by the lack of any religious figures in the landscape window presented by Mrs. Frederick W. Hartwell to the Central Baptist Church in Providence, Rhode Island, as a memorial to her late husband. It was the largest commission of its kind the Tiffany Studios undertook. The central motif of a waterfall has a distant kinship with MacDonald's *Algoma Waterfall* (see Fig. 7), painted in 1920. He would not consciously have recalled the Tiffany window, but perhaps some quality in the Algoma landscape could have triggered a mental association. Under the Tiffany window is lettered "My help cometh from the Lord who made heaven and earth." By all accounts, the Group of Seven found the Algoma landscape awe-inspiring. The impulse which drove MacDonald may lie in little more than a selection of something appropriate to the place, but perhaps it is not too far-fetched to see a relationship: the images recall each other. However, any resemblance between the images may be simply fortuitous. Tiffany drew upon a group of images to create his work, and it may be these which MacDonald knew.

18. Bertram Brooker, "Seven Arts," December 29, 1928.

19. George Pepper letter to the Canada Council, 1959. Canadian Group of Painters, The Robert McLaughlin Gallery, Oshawa, archives.

20. Arthur Lismer quoted by Bridges in *A Border of Beauty*, 133.

21. For an interesting discussion of how artists help create national consciousness, see Brian S. Osborne, "Interpreting a nation's identity: Artists as creators of national consciousness," in A.R.H. Baker and G. Biger, eds., *Ideology and Landscape in Historical Perspective* (Cambridge: Cambridge University Press, 1992), 230 ff.

PRECURSORS TO TOM THOMSON AND THE GROUP OF SEVEN

he Group of Seven can be seen as part of a wave which continued to build slowly, underground, in the decade after 1910. It peaked in 1920, stayed at that level for about eight years, then slowly subsided to become part of another wave which reached its height in 1933 with the formation of the Canadian Group of Painters. At the beginning of the period, when Thomson, MacDonald, Lismer, Varley, Johnston, and Carmichael worked at various commercial-art establishments in Toronto, they greatly admired painters who recognized the intrinsic beauty of the Canadian landscape, particularly William Cruikshank and C.W. Jefferys. A realist influenced by Jean François Millet, Cruikshank challenged traditional ideas about art by painting *habitants* and their activities on the grand scale usually reserved for religious subjects in Canada. Jefferys was more involved with the western landscape. Both he and Cruikshank used pigments in a rougher style than the smooth blending favoured by the Royal Canadian Academy, as the younger generation observed. Another influence was Maurice Cullen, who pioneered the use of Impressionism and Canadian subjects in Canada. "To us, he was a hero," Jackson said. Frederick Challener, known for outdoor sketching in Toronto, as well as for his murals at the Royal Alexandra Theatre and striking commercial work, helped lead the way for them to practise working in the open to record precise effects of light and atmosphere. MacDonald wrote about the influence on him of the Toronto Art Students' League, founded in 1886, with its motto of "No Day Without a Line" and habit of daily sketching, as well as that of G.A. Reid, the principal of the Ontario College of Art, who was also known for his City Hall murals.

PREVIOUS PAGES: *F. S. Challener,* Lambton Mills *(detail), 1891.*

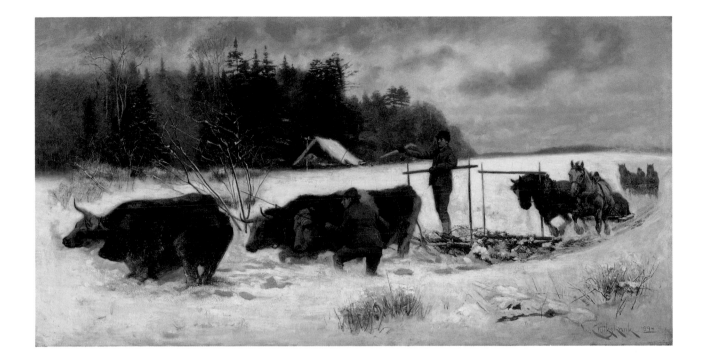

PLATE I

WILLIAM CRUIKSHANK (1848-1922)

Breaking a Road, 1894

Oil on canvas.
93.0 x 175.6 cm (36⅝ x 69⅛ in)
National Gallery of Canada, Ottawa
Purchase, 1913

When Cruikshank showed this painting at various North American and English exhibitions, it must have struck a distinctly Canadian note when compared with the work of expatriate Canadians, such as William Blair Bruce. Scottish by birth, Cruikshank had had thorough schooling in academic art: he had trained in Edinburgh, at the Royal Scottish Academy; in London, at the Royal Academy School; and in Paris, at the Atelier Yvon. He was a member of the Toronto Art Students' League, which MacDonald mentioned as having an influence on the Group of Seven, and a teacher at the Central Ontario School of Art (later the Ontario College of Art) for some twenty-five years, where he taught MacDonald, Thomson, and Carmichael. MacDonald spoke of this particular painting as significant, probably because of the way Cruikshank rendered the snow and distant forest. In 1932, A.H. Robson, who had been MacDonald's boss at Grip Ltd., wrote that the painting showed Cruikshank's "superb draughtsmanship." "The fine drawing in the oxen, the detail of the early sleigh, the vivid presentation of the whole story of road breaking in pioneer days is well presented," Robson said in his book Canadian Landscape Painters.

MAURICE CULLEN (1866-1934)

On the St. Lawrence, 1897

Oil on canvas
53.7 x 72.7 cm (21⅛ x 28⅝ in)
Art Gallery of Ontario, Toronto
Gift from the Reuben and Kate Leonard Canadian Fund, 1926

The Group of Seven admired Cullen's treatment of snow and light, as well as his Canadian subject-matter. He had studied in Paris at the Ecole des Beaux-Arts, the Académie Colarossi, and the Académie Julian. As early as 1891 he had shown an inclination toward Impressionism. He returned to Canada in 1895, and brought to his Canadian subjects a strong handling, heavy impasto, and fresh colour with crisp outlines and simplified forms. Robson, in Canadian Landscape Painters *(1932), wrote about* On the St. Lawrence: *"This painting illustrates his ability to grasp the salient features of the St. Lawrence country and depict with unusual charm the play of sunlight on the snow."*

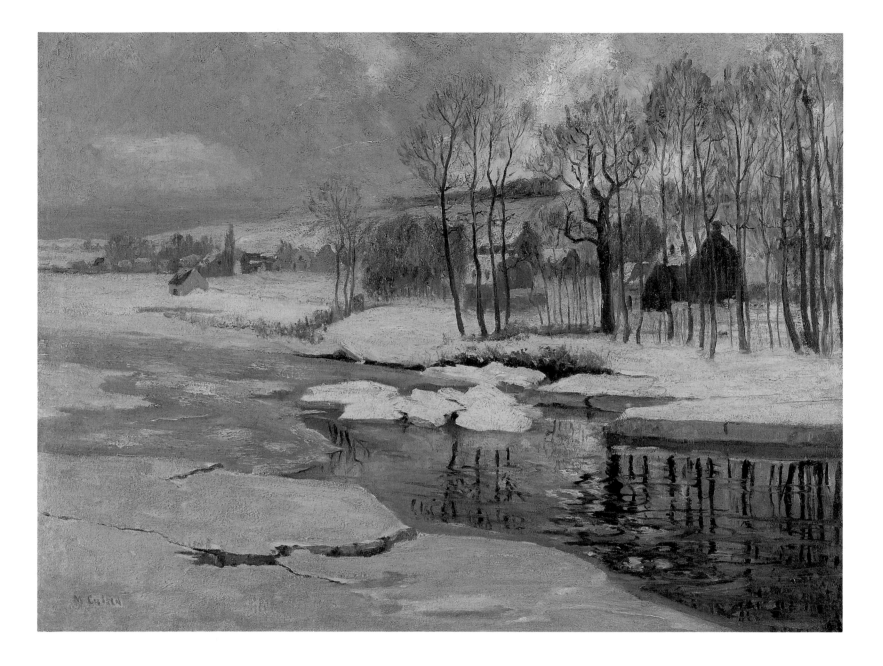

PLATE 3

MAURICE CULLEN

Spring Break-up at Beaupré, 1910

Oil on canvas

76.2 x 101.6 cm (30 x 40 in)

Agnes Etherington Art Centre, Queen's University, Kingston

Gift of D.I. McLeod, 1944

PLATE 4

C. W. JEFFERYS (1869-1951)

A Prairie Trail ("Scherzo"), 1912

Oil on canvas

90.8 x 128.9 cm (35¾ x 50¾ in)

Art Gallery of Ontario, Toronto

Gift of the Canadian National Exhibition Association, 1965

Members of the blossoming Group of Seven admired Jefferys's prairie subject matter and luminous colour scheme. A member of the Toronto Art Students' League, and then a founder-member of the Mahlstick Club (1904-1908), to which MacDonald belonged, Jefferys believed in daily sketching out-of-doors.

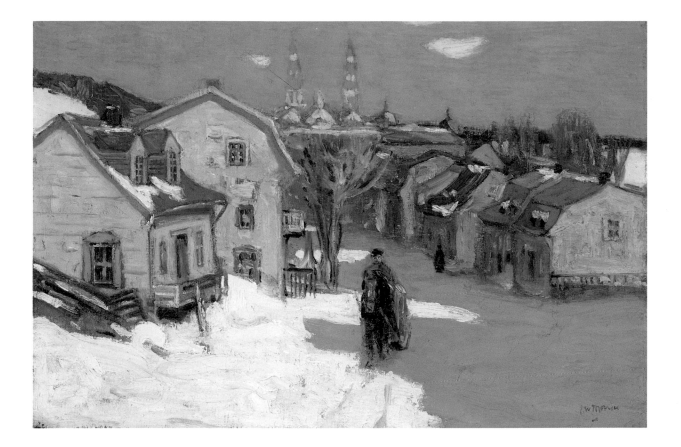

PLATE 5

JAMES WILSON MORRICE (1865-1924)

Sainte-Anne-de-Beaupré, 1897

Oil on canvas
44.4 x 64.3 cm (17½ x 25¼ in)
The Montreal Museum of Fine Arts
William J. Morrice bequest, 1943

Jackson said that it was through Cullen and Morrice that Montrealers first became aware of the fresh and invigorating art movements in France. Jackson might have known of paintings such as Sainte-Anne-de-Beaupré, which was probably shown at the Art Association of Montreal in 1897. In it, Morrice lavished attention on snow, later such an important subject for the Group of Seven. The kind of colour contrast, pale red and green, which Morrice used on the façade of the house to the right in the picture would have been fascinating for painters such as Jackson, who would have seen in it the influence of Post-Impressionism. Eugène Chevreul had written of the vitality to be gained through the use of contrasting colours; painters such as Van Gogh had experimented with his ideas, particularly through the use of red and green, though Morrice's painting is more delicate and luminous than bold.

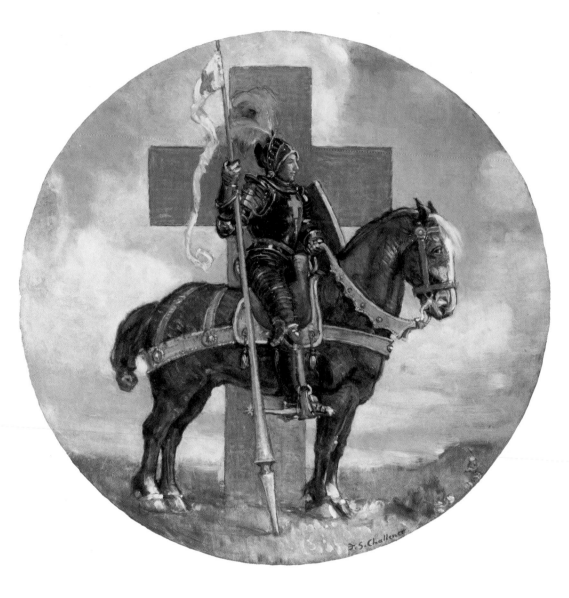

PLATE **6**

F. S. CHALLENER (1 8 6 9 - 1 9 5 9)

Red Cross Knight

Oil on masonite

52.1 x 45.4 cm (oval) (20½ x 17⅞ in)

Private collection

Challener, a member of the Toronto Art League, sketched out-of-doors at an early date and used the sketches to develop paintings, such as Lambton Mills. *The later members of the Group of Seven admired his Toronto subjects as well as his more commercial work. His* Red Cross Knight *is proof of his solid knowledge of draughtsmanship and the figure.*

PLATE 7

F. S. CHALLENER

Lambton Mills, 1891

Oil on canvas

47.0 x 34.6 cm (18½ x 13⅝ in)

Art Gallery of Ontario, Toronto

Purchase, Peter Larkin Foundation, 1966

COMMERCIAL ART

The background of most of the members of the Group of Seven lay in commercial art, and especially work with Toronto's Grip Ltd. The company had been named for a humorous and political illustrated paper, started in Toronto in 1873 by John W. Bengough, one of Canada's pioneer cartoonists. In time, the publication failed, but its art and engraving department continued under the old name. About 1905 the commercial artists on the staff began to take an interest in landscape painting. Through contacts with members of the Toronto Art League and the Mahlstick Club, the group began weekend sketching trips, with the firm's encouragement: Canada's prospering railways needed posters and artwork which favourably portrayed northern districts, as A.H. Robson, who was head at Grip, and then at Rous and Mann, said. He added: "The railways were demanding bright, attractive folders and posters portraying the charm of our northern districts and these men were in a position to produce something of the true spirit of the country." At Grip itself, MacDonald solidly supported the shift in focus. With him were such men as Lismer, Carmichael, Varley, and Thomson, among many others. That the group at Grip provided a sense of camaraderie and support for the new movement can be gleaned from the few statements of the men who worked there. "A fine spirit pervaded the Art Room and through all the fun and the pranks we managed to turn out a high standard of work," wrote one of them, Leonard Rossell.[1] Advertising work, with its demand that the artist meet a schedule, and the way it dealt with ideas, also influenced the work habits of members of the Group. Thomson's *Quotation from Maeterlinck* (Pl. 8) shows the kind of penmanship and subject-matter used by early commercial artists. By 1912, when Thomson, Carmichael, and Varley joined the art department of Rous and Mann, they were beginning to sense that their future lay in fine, and not commercial, art. Their work reflected the change. It was in 1911 that Thomson began to regard painting seriously; he got his painting outfit in 1912 and that year made regular sketching trips to the Humber River with Frank H. (Franz) Johnston, and to other places, such as Lake Scugog, with other friends from Grip.

The new enthusiasm for northern imagery can be sensed in an early bookplate prepared by MacDonald for Dr. MacCallum (Pl. 9). Strong design work of this kind is but a short step from painting. A later example, an advertisement by Carmichael for The Bigwin Inn (Pl. 10), is more sophisticated, particularly with its unusual two-dimensional surface pattern.

1. L. Rossell, "The Grip" (unpublished account), National Gallery of Canada Library, Ottawa.

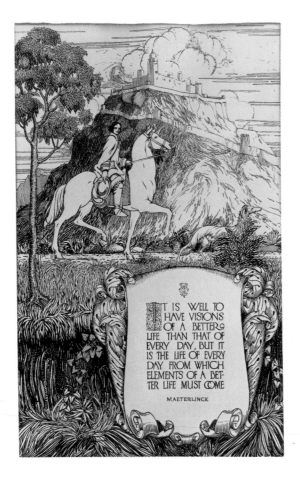

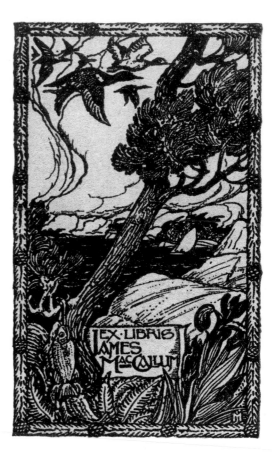

PLATE 8

TOM THOMSON

Quotation from Maeterlinck, c. 1908?

Pen on paper
34.3 x 20.6 cm (13½ x 8⅛ in)
Private collection

PLATE 9

J. E. H. MACDONALD

Ex Libris James MacCallum

Bookplate
Paper: 12.0 x 10.3 cm (4⅞ x 4¹/₁₆ in)
Image: 7.7 x 6.1 cm (3¹/₁₆ x 2⁷/₁₆ in)
McMichael Canadian Art Collection Library Archives, Kleinburg
Gift of Mrs. Marjorie Lismer Bridges, Ashton, Maryland

Thomson was a lettering man at Grip. As an assistant to MacDonald, he finished details left undone by individuals who had more talent at drawing the figure. The illustrative style of this sketch, which echoes illustrators from the Glasgow School of Art and William Morris, among other sources, demonstrates his virtuoso ability with the pen. Later, in his landscape sketches, Thomson used a brush with equal deftness.

PAGE 36: *Franklin Carmichael,* The Bigwin Inn (*detail*), 1928

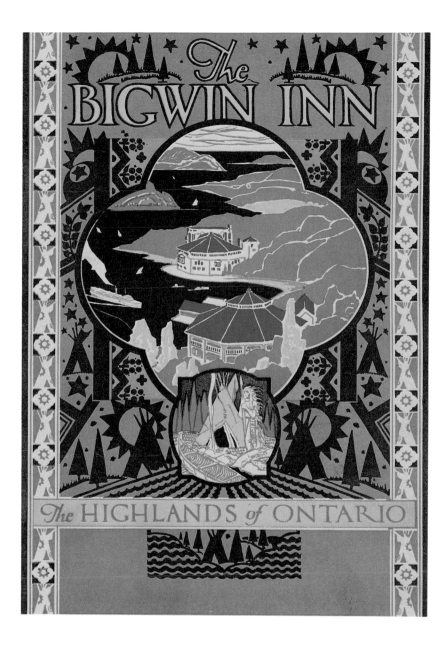

PLATE 10

FRANKLIN CARMICHAEL

The Bigwin Inn, 1928

Brochure
19.7 x 14.0 cm (7¾ x 5½ in)
McMichael Canadian Art Collection Library Archives, Kleinburg
Gift of Mrs. R.G. Mastin, Toronto

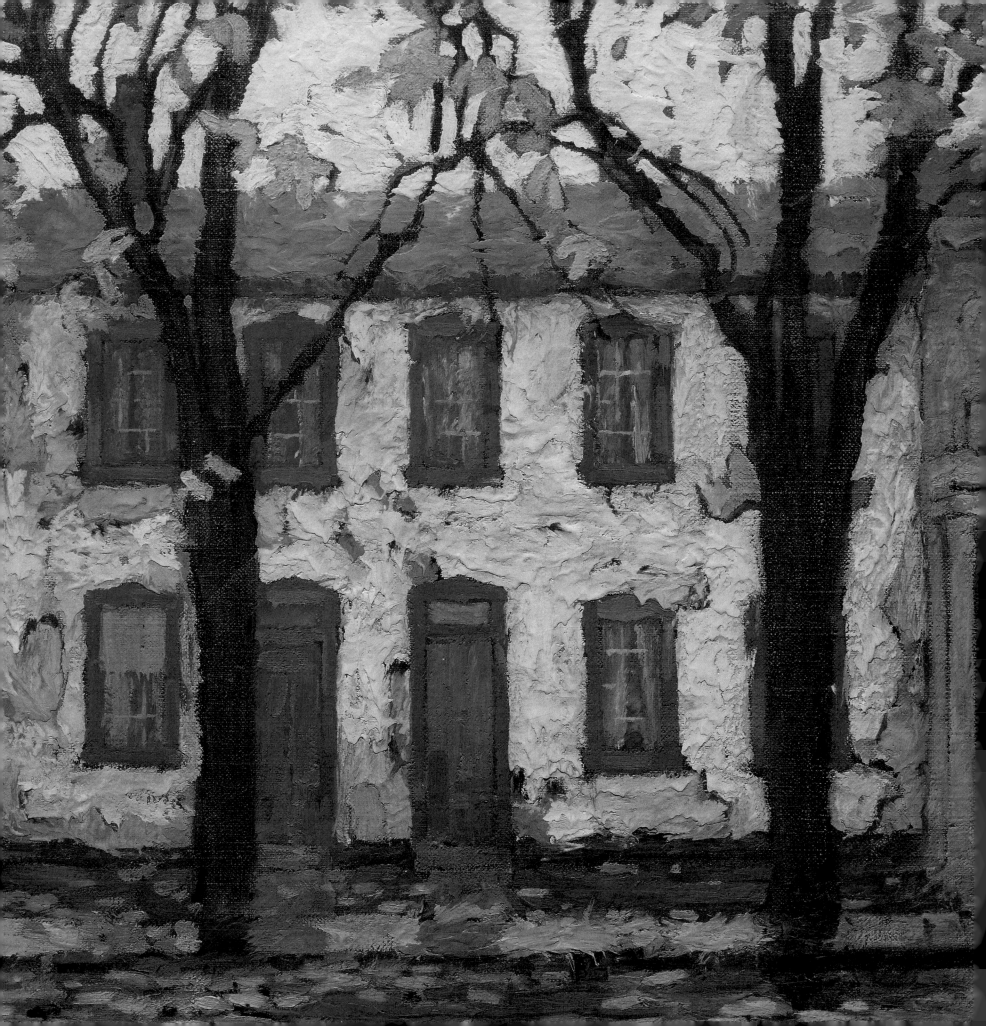

TOM THOMSON AND MEMBERS
OF THE GROUP OF SEVEN

Tom Thomson, 1877-1917

Died before the Group was formed

ORIGINAL MEMBERS

Franklin H. Carmichael, 1890-1945

Lawren Harris, 1885-1970

A.Y. Jackson, 1882-1974

Frank H. (Franz) Johnson, 1888-1949

(only showed in first exhibition)

Arthur Lismer, 1885-1969

J.E.H. MacDonald, 1873-1932

F.H. Varley, 1881-1969

INVITED MEMBERS

1926: A.J. Casson, 1898-1992

1931: Edwin Holgate, 1892-1977

1932: L.L. FitzGerald, 1890-1956

OPPOSITE: *Lawren Harris,* Houses, Chestnut Street *(detail), 1919*

PLATE II

J.E.H. MACDONALD

The Sleighing Party, Winter Moonlight, c. 1911

Oil on canvas

41.3 x 51.0 cm (16¼ x 20⅛ in)

Montreal Museum of Fine Arts

Gift of Claude Laberge, 1984

MacDonald was one of the few members of the Group which was gathering who often painted the figure in motion, or, as here, traversing the landscape. Naturally enough, it is the quality and colour of the snow which he particularly investigates. The sleighing party takes place at night, under a full moon. It was from MacDonald that Thomson took the idea of doing nocturnes.

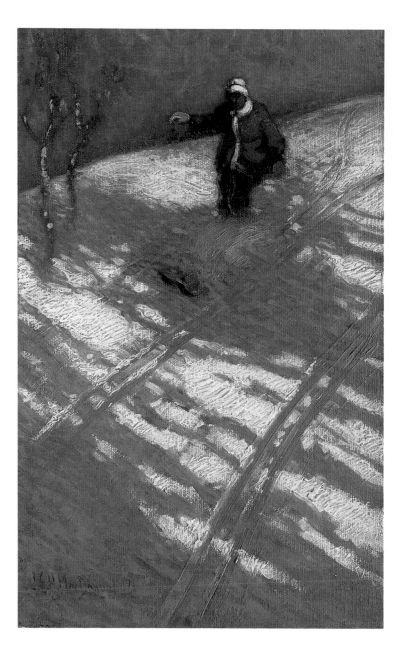

PLATE 12

J. E. H. MACDONALD

Skiing, 1912

Oil on canvas

46.3 x 28.6 cm (18¼ x 11¼ in)

McMichael Canadian Art Collection, Kleinburg

Purchase, 1984

PLATE 13

TOM THOMSON

The Drive, 1916-17

Oil on canvas

120.0 x 137.5 cm (47¼ x 54⅛ in)

University of Guelph Collection, Macdonald Stewart Art Centre, Guelph

Ontario Agricultural College purchase with funds raised by students, staff, and faculty, 1926

The Drive (right) *was one of Harris's first monumental Canadian landscapes: it was his first to depict Northern Ontario. The lumber drive as a subject appealed to the members of the nascent Group of Seven, who regarded themselves in a heroic light. Somewhere in their minds, they saw themselves as painters who were clearing out "dead wood." As MacDonald wrote in 1916, in a newspaper article defending the Group, "It is evident that a drive of some kind is on." Thomson, who in his work often seems to "talk" to his painter friends, may have been inspired by MacDonald's words to paint his own version. In Algonquin Park, he enjoyed following the lumberjacks and often painted them at work, their equipment, or the place they lived. His painting has greater vitality because he studied the subject firsthand.*

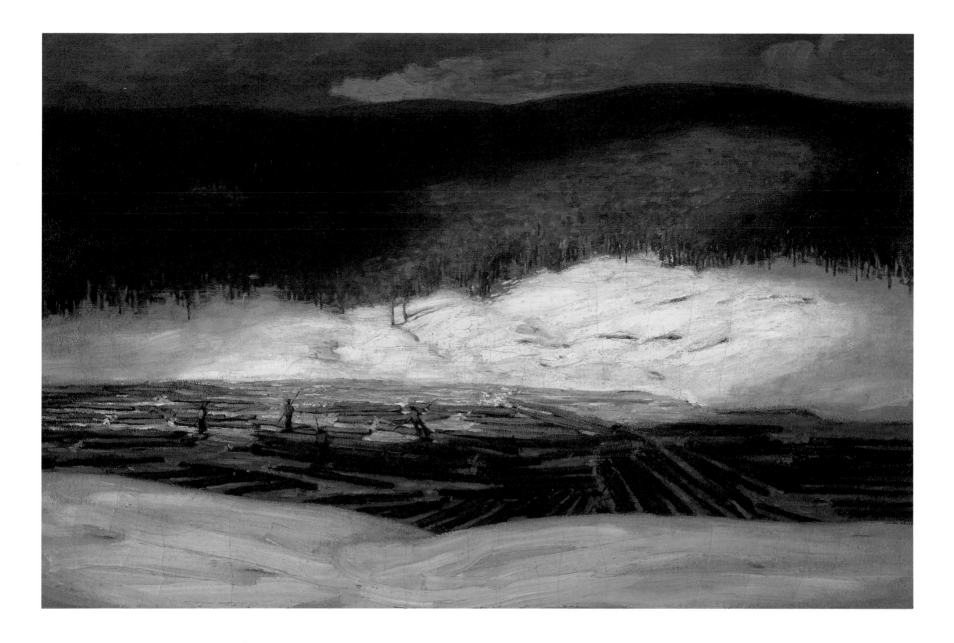

PLATE 14

LAWREN HARRIS

The Drive, 1912

Oil on canvas

90.7 x 137.6 cm (35¾ x 54⅛ in)

National Gallery of Canada, Ottawa

Purchase, 1912

PLATE 15

A. Y. JACKSON

The Edge of the Maple Wood, 1910

Oil on canvas
54.6 x 65.4 cm (21½ x 25¾ in)
National Gallery of Canada, Ottawa
Purchase, 1937

After two years of study in France, starting in 1907, Jackson returned to Canada and painted at Sweetsburg, Quebec. "It was good country to paint," he said, "with its snake fences and weathered barns . . . the boulders too big to remove, the ground all bumps and hollows." He noted the sap pails still on the trees that spring. His observations are recorded in this painting, which shows a boulder in the middle of the field, a snake fence, and several sap pails. The work's native flavour impressed MacDonald and Harris. Thomson claimed that this painting opened his eyes to the possibilities of the Canadian landscape. Later, Thomson often used the motif of the shadow of the tree in the foreground of the picture.

The purchase of this canvas by Harris, and his warm encouragement, brought Jackson from Montreal to Toronto.

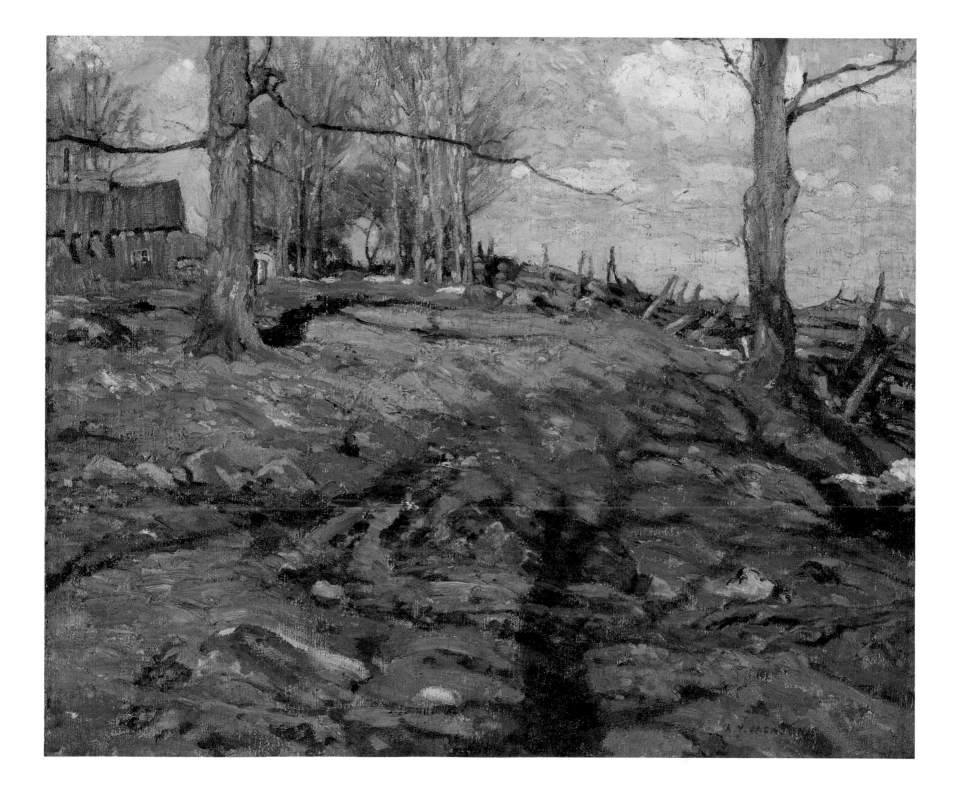

PLATE 16

A. Y. JACKSON

Terre Sauvage, 1913

Oil on canvas
128.8 x 154.4 cm (50¾ x 60¾ in)
National Gallery of Canada, Ottawa
Exchange, 1936

This is the first canvas Jackson painted in Toronto; he used Lawren Harris's studio in the fall of 1913. The painting has the air of a formal statement: it tells something about the north country, and it is painted in a new way, with bold Fauvist strokes and forceful, idiosyncratic shapes. Jackson's trees often have unusual forms. The tree at right seems to point like an arrow, as do several of the trees at centre. The bow of a rainbow, at left, which arches over the scene, adds to the splendour of the whole. The painting has the happy quality of discovery. The North, the "Terre Sauvage" of the title, was, for Jackson, a "new found land."

Jackson's friends reacted strongly to the work, which seemed to them a premonition of a new style. Thomson's patron, Dr. MacCallum, brought him to see it and meet Jackson. Their friendship stemmed from this moment.

The painting was titled "Mount Ararat" by J.E.H. MacDonald because it looked to him like the first land that appeared after the Flood subsided. Jackson developed it from sketches he had made while canoeing in Georgian Bay, as indicated by the section of the rocky Canadian Shield it shows.

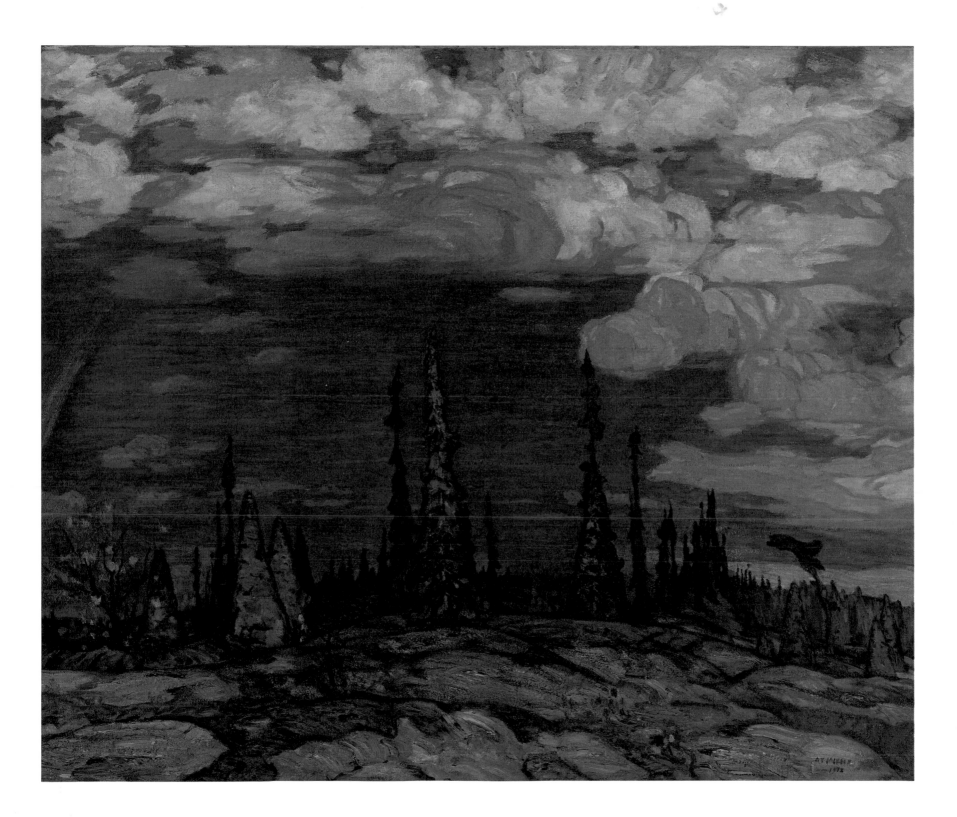

LAWREN HARRIS

Hurdy-Gurdy, 1913

Oil on canvas
75.8 x 86.6 cm (29⅞ x 34⅛ in)
Art Gallery of Hamilton
Gift of Roy Cole, 1992

This early canvas by Harris was only recently given to the Art Gallery of Hamilton; it has not been on exhibit to the public for many years. The scattered autumn leaves and lively Impressionistic handling recall other early urban scenes by Harris, but the presence of the organ-grinder's cart and the group of nearby children demonstrate Harris's gift for painting the figure. One feature of the painting, rare in Harris's work, is his use of a diagonal placement to the street; he generally preferred a frontal view. A reviewer said of another work he exhibited in 1913 that it was an example of the beauty of the commonplace. This description could also be said to apply to Hurdy-Gurdy.

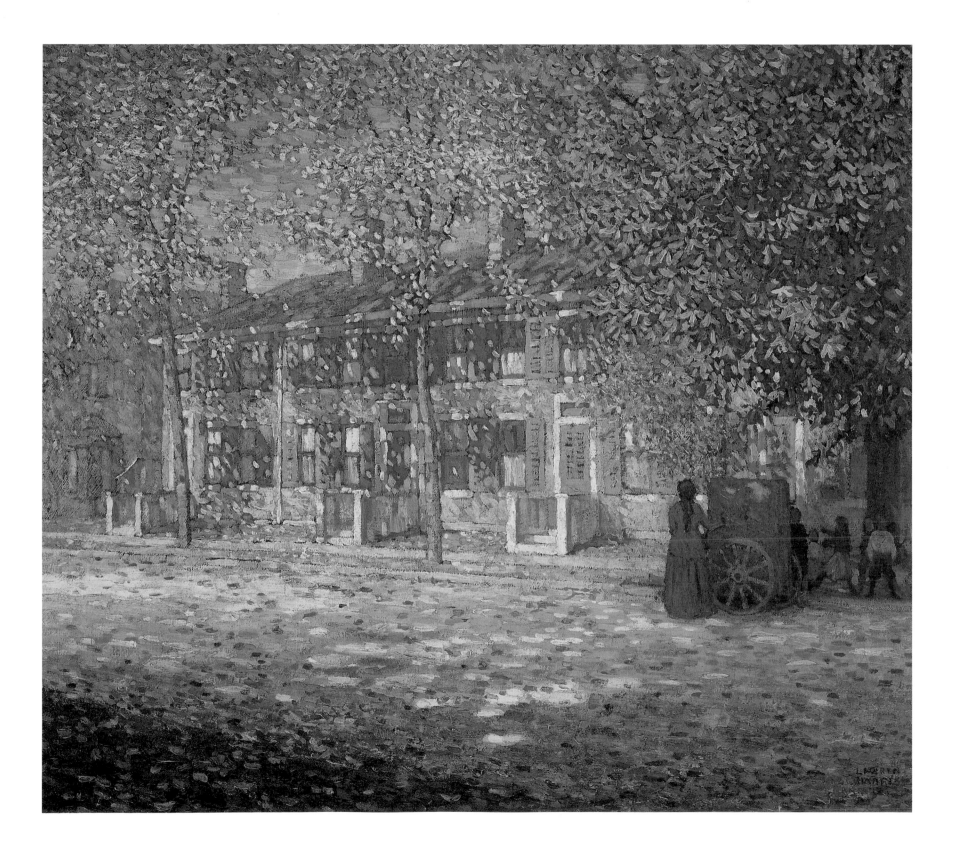

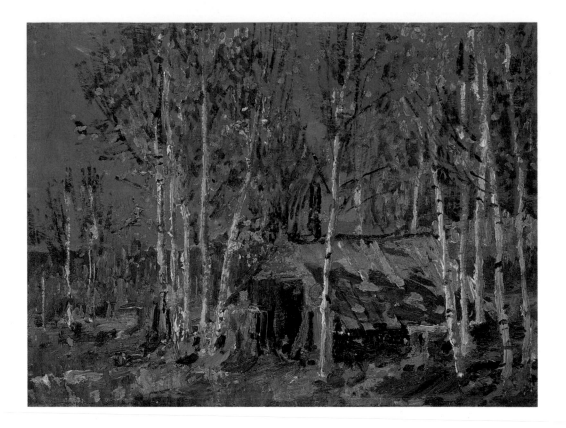

PLATE 18

ARTHUR LISMER

Study for *The Guide's Home, Algonquin Park*, 1914

Oil on panel
23.5 x 31.5 cm (9¼ x 12¼ in)
National Gallery of Canada, Ottawa
Bequest of Dr. J.M. MacCallum, 1944

As was true of Jackson, Lismer was under Thomson's spell at this moment: the painting's rich colour shows his influence. The Impressionistic handling is probably the result of talks with Jackson, who had studied in France, heard of Impressionism there, and had books on the subject. He told the others how to use separate colours in clean-cut dots. The Guide's Home, *along with Thomson's* Pine Island, Georgian Bay *and a smaller Thomson canvas and sketches, are some of the high points of Impressionist style in Canada. Jackson summed up the problem of the style succinctly: "It was too involved a technique to express the movement and complex character of our northern wilds."*

The figure of a man stands near the door of this cabin in Algonquin Park. It could be one of the two who shared the home, George Rowe, a guide and general handy man, or Larry (Lowrie) Dickson, who worked part-time at Mowat Lodge.

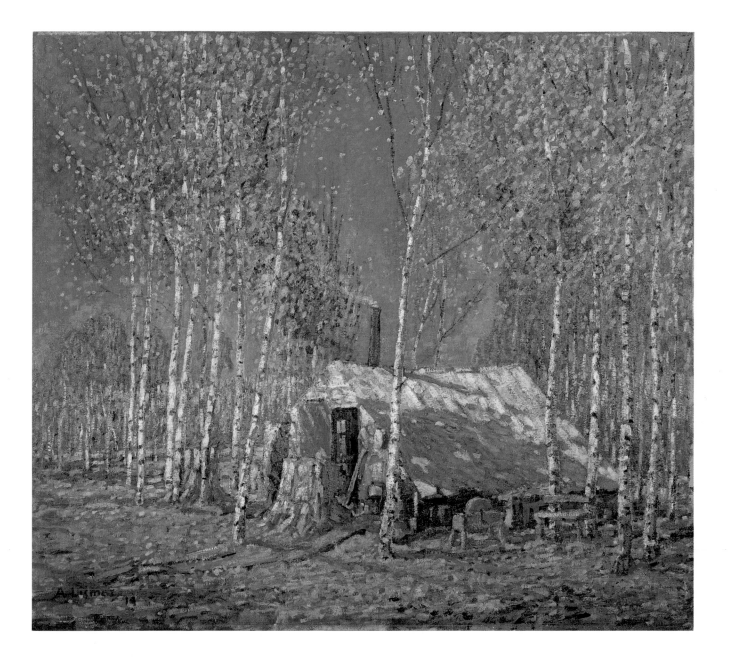

PLATE 19

ARTHUR LISMER

The Guide's Home, Algonquin, 1914

Oil on canvas
102.6 x 114.4 cm (40⅜ x 45 in)
National Gallery of Canada, Ottawa
Purchase, 1915

PLATE 20

TOM THOMSON

Sketch for *Northern River*, 1914-15

Gouache on paper
29.9 x 26.5 cm (11¾ x 10⁷⁄₁₆ in)
Art Gallery of Ontario, Toronto
Purchase, 1982

Though usually critical of his own work, Thomson once confided to a nephew that, of all his works, he thought this painting "not half bad." He may have unconsciously chosen a title which recalled the poem Northern River, *by the poet Wilfred Campbell. Thomson's canvas is poetic in essence. It is also mysterious. For many, the thick, interwoven branches and dark foreground, as well as the quiet mood, recall the feeling of a church interior.*

In the gouache sketch for the painting, the bright blues of the foreground and cheerful tones in the distance suggest that Thomson may have intended brighter colour in the canvas. As always in his work, the painting stabilizes what is fleeting and accidental in the sketch, as well as using certain compositional devices, such as additional space in the foreground, to distance the canvas from the viewer and give more grandeur to the conception.

The locale depicted by Thomson in the sketch is unknown, although some said what he called his swamp picture was done outside Algonquin Park. The use of gouache, an opaque poster-paint material, suggests this work was done early in Thomson's career, since he prepared design work in this medium. He left the commercial field in 1913. When the painting was exhibited in 1915, it was called the most striking in the show. A Toronto correspondent to The Christian Science Monitor *spoke of the "virile rendering" of the tangled confusion of the fringe of the forest and mentioned the ruddy glow of the setting sun. "It revels," he said, "in what the rest of the world might consider the country's defects." Today the painting is such a well-known part of Canadian art that it is reproduced on t-shirts and placemats for sale in art gallery shops.*

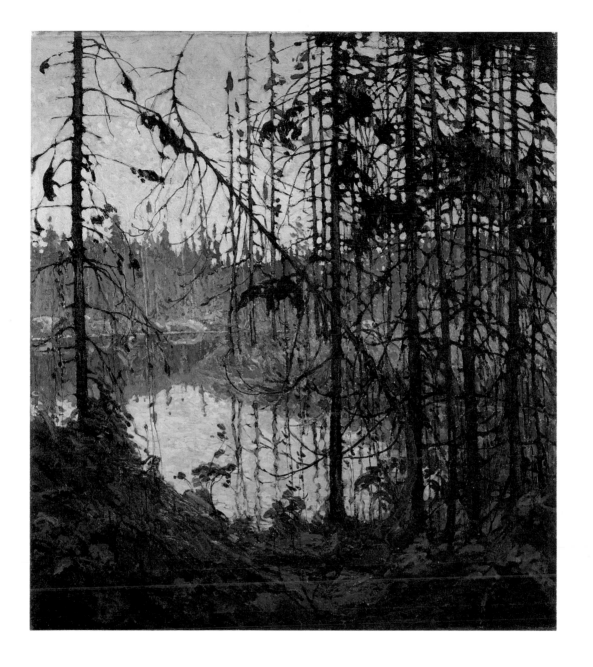

PLATE 22

ARTHUR LISMER

Sunglow, 1915

Oil on canvas

49.3 x 45.5 cm (19⅜ x 17⅞ in)

Art Gallery of Nova Scotia, Halifax

Lismer had been friendly with Thomson from 1911, when he joined the staff of the commercial-art firm of Grip Ltd. in Toronto. In the spring of 1914, he went to Algonquin Park for the first time to sketch with Thomson. He returned that fall to make a record of the season. Thomson described the scene in a letter to his friend Dr. MacCallum: Lismer, he said, was "greatly taken with the look of things here. . . . The maples are about all stripped of leaves, but the birches are very rich in colour." Lismer wrote MacCallum that he was finding it far from easy to express the riot of full colour. When he got back to Toronto, he developed one of his sketches into The Guide's Home, Algonquin *(Pl. 19); he also painted this small canvas. The fussy, tentative handling and crusty impasto of the hillside trees recalls Thomson's work done in the park that fall, which Lismer would have seen in the shack Carmichael and Thomson shared that winter, since he often had lunch with them.*

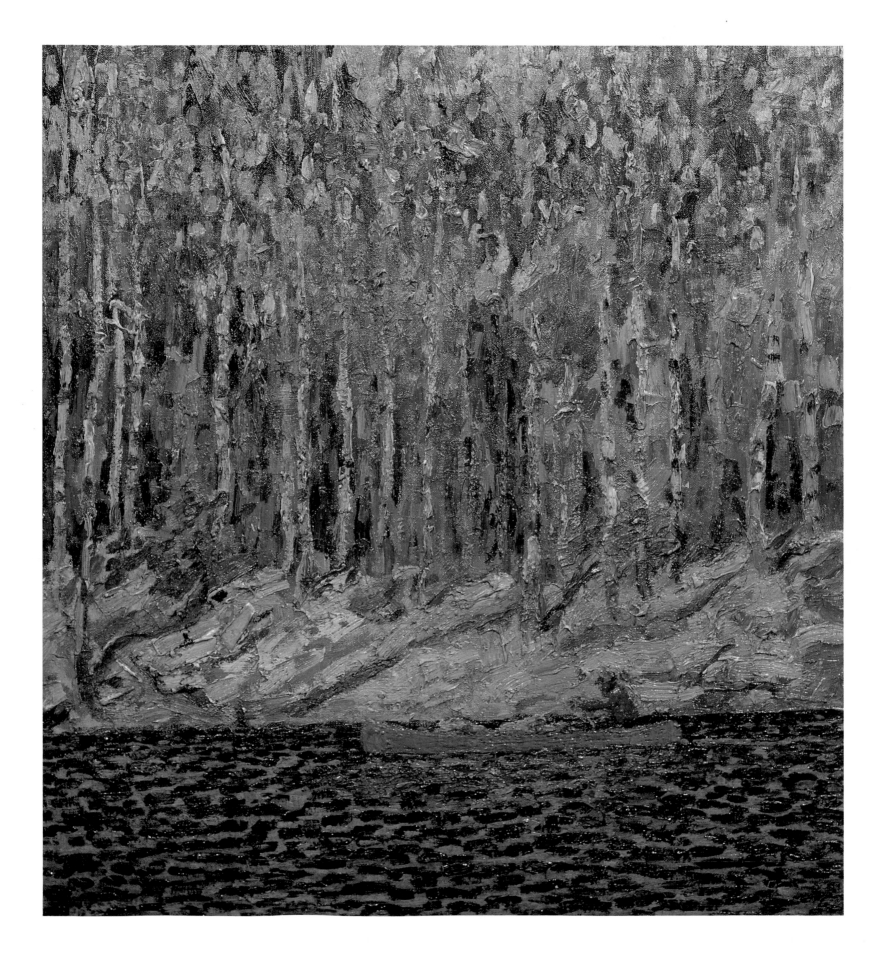

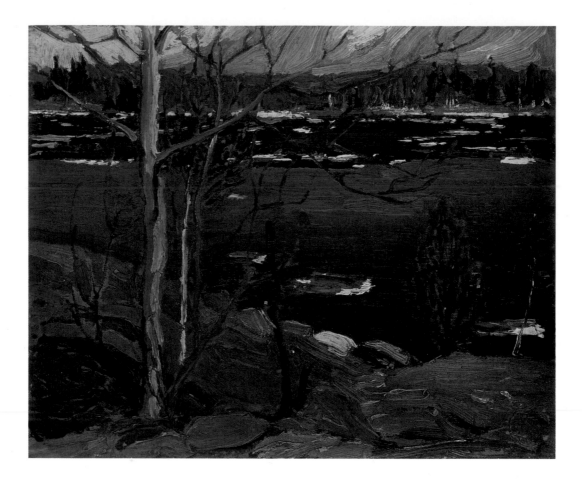

PLATE 23

TOM THOMSON

Study for *Spring Ice*, 1915

Oil on cardboard
21.6 x 26.7 cm (8½ x 10½ in)
National Gallery of Canada, Ottawa
Bequest of Dr. J.M. MacCallum, Toronto, 1944

One of the few successes Thomson had in his lifetime was the sale in 1916 of Spring Ice *to the National Gallery of Canada. The painting has an ephemeral and lyrical quality. It records a moment that passes quickly: the breaking up of the spring ice. Note in it the delicate counterpoint of spatial relations: a branch almost like a hand reaches out to other branches across an open space. Thomson may have been thinking of matters far from Algonquin Park. That the work is a closely witnessed record of a temporal and climatic condition in nature is clear from the sketch, although if we compare the two, we realize all the more clearly what a masterly painter Thomson was. In the final version, the scene has far more liveliness, dimension, and colour, and better design.*

PLATE 24

TOM THOMSON

Spring Ice, 1915-16

Oil on canvas

72.0 x 102.3 cm (28⅜ x 40¼ in)

National Gallery of Canada, Ottawa

Purchase, 1916

PLATE 25

TOM THOMSON

The Pointers (also known as *Pageant of the North*), 1915-16

Oil on canvas
101.6 x 114.3 cm (40 x 45 in)
Hart House Collection, University of Toronto
Purchase, 1928-29

The "pointers" of the title refers to the distinctive, flat-bottomed boats used by loggers (three of them are shown in the canvas). Thomson took his ideas about picture-making and recording the scene before him to a new height in this painting in which rounded cumulus clouds sail lazily toward the bands of horizontal clouds behind the hills. The colourful panorama of the trees in the fall in Algonquin Park is developed through dabs of blue, orange, pink, yellow, and green on an orange-brown ground. White strokes delineate trees; the rapidly flowing water has short brush strokes of blue, green, yellow, orange, pink, and yellow.

The painting's other title — Pageant of the North — has a majestic ring, and the spectacle of the procession of the loggers' boats is formal, and celebratory. For Thomson, the lumber industry provided colour in the North.

Bateaux (right) shows the loggers' boats from a closer perspective. Loggers balance on the log jam in the middle distance.

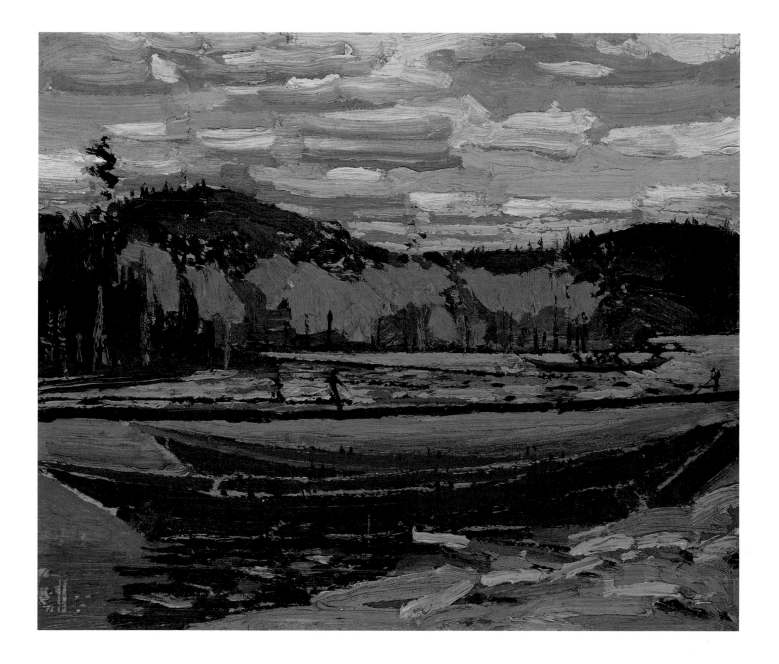

PLATE 26

TOM THOMSON

Bateaux, C. 1916

Oil on panel
21.6 x 26.7 cm (8½ x 10½ in)
Art Gallery of Ontario, Toronto
Gift from the Reuben and Kate Leonard Canadian Fund, 1927

PLATE 27

TOM THOMSON

In the Northland, 1915

Oil on canvas

101.7 x 114.5 cm (40 x 45⅛ in)

Montreal Museum of Fine Arts

Gift of the Friends of the Montreal Museum of Fine Arts, 1922

In In the Northland, *Thomson used a subject which was a commonplace in his work: a view of the shoreline of Algonquin Park from a nearby vantage point in which a rocky foreground bounded by trees leads to the cold blue waters of a lake and the cobalt sky in the background. Yet here he elevates the subject, treating it with unusual care to help the viewer focus: the fallen tree points the viewer's eye to the distance. The shadows of the birches, the orange ground cover, and the pink and grey rocks create a carpet-like effect. The contrast of the dark blue of the water and the fall colours enhances the rich, luxurious feeling of the scene. Nature is a treasure house, Thomson seems to say. His use of vivid colours, and strong design, came partly from his background in commercial art and partly from his own love of colour.*

Thomson thought of the land as a refuge from the increasing complexities of the modern-day world — here he seems, along with the viewer, to look out from some private, protected place. He may also have chosen to paint such places because of the overgrown vegetation of Algonquin Park, which made travel difficult other than by water.

PLATE 28

LAWREN HARRIS

Spruce and Snow, Northern Ontario, 1916

Oil on canvas
102.3 x 114.3 cm (40 x 45 in)
Art Gallery of Ontario, Toronto
Gift of Roy G. Cole, Rosseau, Ontario, 1991

In 1913, Harris and MacDonald saw a large exhibition of modern Scandinavian painting at the Albright Gallery in Buffalo. They were most attracted to the work of Gustav Fjaestad and Hârâld Sohlberg. Fjaestad's winter scenes, with their high foreground fields of snow and delicate, finely harmonized colour schemes, may have influenced Harris's winter landscapes, as here.

Art historian Jeremy Adamson calls Harris's winter landscapes decorative, since the forms are highly stylized. The brushwork, which is composed of arbitrary patterns that stress the two-dimensional nature of the work, and the juxtaposition of thick strokes of complementary hues, were more likely influenced by the painstaking divisionist technique of the Swiss Impressionist Giovanni Segantini (1858-1899), who applied thin strokes of impasto paint, leaving a space between each stroke, which he filled with complementary colours. Despite these diverse sources, Harris created a winter scene with a strongly Canadian quality. The austere tone, lyrical colour, and structural treatment are typical of his work during this period. The sky in the background seems to have been influenced by Thomson, who had used a similar effect in The Pointers *(Pl. 25), and later in* The Jack Pine *(Pl. 37). Yet both of these works of Thomson's recall Harris in the square shape of the canvases, the generally decorative quality, and boldly interwoven strokes of paint. Clearly the two men influenced each other. After Thomson's death, Harris wrote warmly of his remoteness, genius, and reticence.*

TOM THOMSON

Forest, October, 1916

Oil on panel

20.9 x 26.6 cm (8³⁄₁₆ x 10⁹⁄₁₆ in)

Art Gallery of Ontario, Toronto

Gift from the J.S. McLean Collection, 1969, donated by the Ontario Heritage Foundation, 1988

The last fall of Thomson's life is considered the high point of his career — the work he produced then has the most brilliant colour and the greatest verve of handling. This sketch, which elegantly characterizes the complex spatial relations of branches and trees in the heart of the forest, is one of his most brilliant depictions of the season. Into a small format Thomson packs drama and movement: the branches, trees, and their shadows are set in opposition, a space is carved out, and the sky opens up the top of his closed-in scene. Thomson always used a touch of blue to expand the view. He didn't want the effect of the forest interior to be claustrophobic; he wanted "light in it," as Dr. James MacCallum, an ophthalmologist by profession, and one of the sparks in the creation of the Group of Seven, recorded on the back of a related sketch.

Interestingly enough, in this season, Thomson painted some semi-abstractions on the backs of a few of his sketches. Works like this, which are pared down to the essentials, give an effect of hovering on the borderline between reality and abstraction. Thomson probably meant them as on-the-spot records, however.

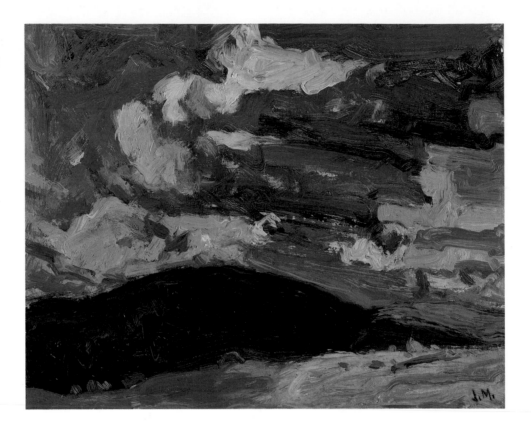

PLATE 30

J. E. H. MACDONALD

Storm Clouds (sketch for *The Elements*), c. 1915

Oil on pressed board
20.2 x 25.4 cm (7¹⁵⁄₁₆ x 10 in)
McMichael Canadian Art Collection, Kleinburg
Gift of the Founders, Robert and Signe McMichael, 1966

F.B. Housser, whose book A Canadian Art Movement *(1926) was the first to seriously discuss the Group of Seven, said that the task of painting the Canadian landscape demanded a new type of artist: one who divested himself of the velvet coat and flowing tie of his caste, put on the outfit of the bushwhacker and prospector, and grappled with his environment by paddling, portaging, and breaking camp.*

In The Elements, *MacDonald referred to the four elements: earth, air, fire, and water. He also painted the elements considered necessary in the new art — the rocks of the Canadian Shield, pine trees blown by the wind, and men who warm themselves by a fire. The scene is of Jack-knife Island, north of Split Rock near Monument Channel, Georgian Bay. Dr. James MacCallum had a cottage on Monument Channel on Georgian Bay and persuaded MacDonald to paint there. The work is a composite: for the clouds MacDonald used a sketch he had painted in the Laurentians.*

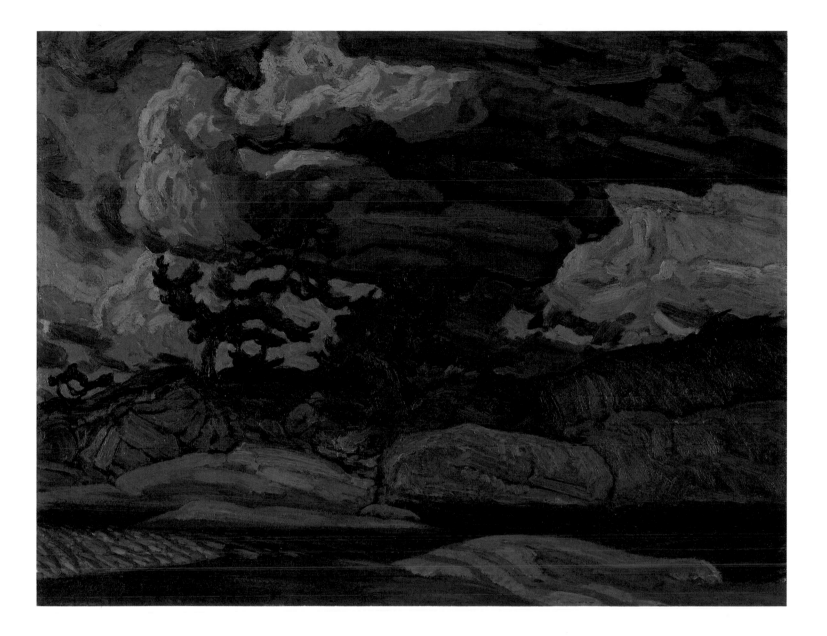

PLATE 32

J.E.H. MACDONALD

Study for *The Tangled Garden*, 1915

Oil on board

20.3 x 25.4 cm (8 x 10 in)

National Gallery of Canada, Ottawa

Gift of Arthur Lismer, Montreal, 1946

In 1913, MacDonald moved to Thornhill, then a village north of Toronto. This painting is of a section of the garden at the back of his house. His extensive preparatory studies in sketchbooks and on panel suggest MacDonald's long meditation on the subject: the study we reproduce is strikingly close to the finished canvas. Art historian Peter Mellen felt the screen the flowers create recalls Thomson's Northern River (Pl. 21); others such as Nancy Robertson Dillow believe that MacDonald might have found a suggestion for its shape in illustrations in European magazines such as Jugend *and in related periodicals to which MacDonald subscribed or to which he had access. The shape of the sunflower also recalls the Art Nouveau style and the school of William Morris, as well as (distantly) Van Gogh. Probably the general source for both Thomson's and MacDonald's strong designs lies in their commercial-art training.*

When this work was shown, one of the critics of the day, Hector Charlesworth, complained about the size of the canvas (he felt it was too large for the relative importance of the subject) and the crude colours. The composition does look jumbled when compared with MacDonald's later work. The feeling of compressed energy in the central flowers is characteristic of this later work, however. West by East, *a book of MacDonald's poetry published in 1933, after his death, included two poems about sunflowers, "Autumn Sunflowers" and "The Sunflower." In the first, the following lines evoke this painting: "The stooping flowers told,/of summer downward wending/Brooding withdrawn and old."*

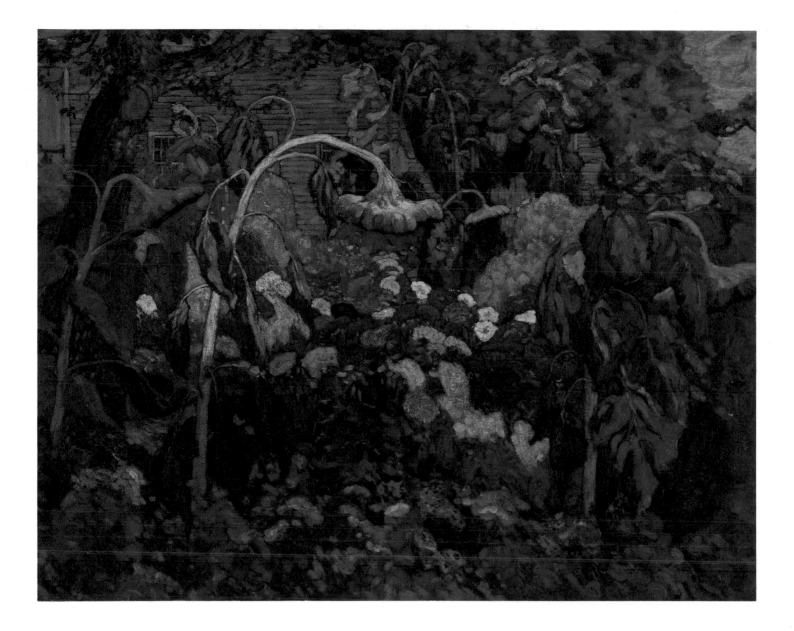

PLATE 33

J.E.H. MACDONALD

The Tangled Garden, 1916

Oil on board
121.4 x 152.4 cm (48 x 60 in)
National Gallery of Canada, Ottawa
Gift by W.M. Southam, F.N. Southam, and H.S. Southam, 1937,
in memory of their brother Richard Southam

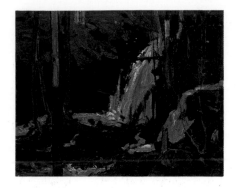

PLATE 34

TOM THOMSON

The Waterfall, 1915

Oil on panel
21.1 x 26.7 cm (8⁵⁄₁₆ x 10½ in)
Vancouver Art Gallery
Presented in memory of Robert A. de Lotbinière Harwood by his friends, 1952

Thomson painted sketches in oils on wooden board when he worked in Algonquin Park, then used the sketches to develop full-scale canvases in the studio in Toronto. He did the sketch for this painting in 1915. We can imagine Thomson discovering with pleasure this oasis of cool tranquillity in the forest: two waterfalls, one a smaller version of the other, create pale patterns of colour set against the darker browns of the forest.

Changes were made in painting the canvas based on this sketch. In his larger work, Thomson liked to distance the image, to place it on a pedestal. In the sketch, the foreground tree (at left) is cut by the edge; in the finished work, it is placed farther back. He also made the finished work more autumnal, adding red leaves to the bushes in the foreground and making the treetops into flat and delicately patterned areas which recall the effect of stained glass. His friend Dr. MacCallum called the large strokes he used in areas such as this "Lawren Harris patent," and Thomson seems to have been strongly influenced by Harris in the winter of 1916, the season of this painting. The use of more solid, three-dimensional forms, as in the foreground rocks, suggests Harris's influence too.

In painting Woodland Waterfall, *Thomson candidly expressed what nature meant to him. The stained-glass effect of the treetops and water, and the way the waterfall is set apart and framed by the forest, evoke the atmosphere of a church interior. Nature was the ultimate shrine for Thomson.*

Much later, in 1937, Martin Baldwin, the director of the (then) Art Gallery of Toronto, said in a record he made of Thomson's work that this painting, then known simply as The Waterfall, *was "unfinished at [the] top — did not 'come off.'" Nor did Jackson rank it among Thomson's best. Yet to the modern eye, the painting looks magical. The gentle beauty of the image merits the more poetic title it has at present —* Woodland Waterfall.

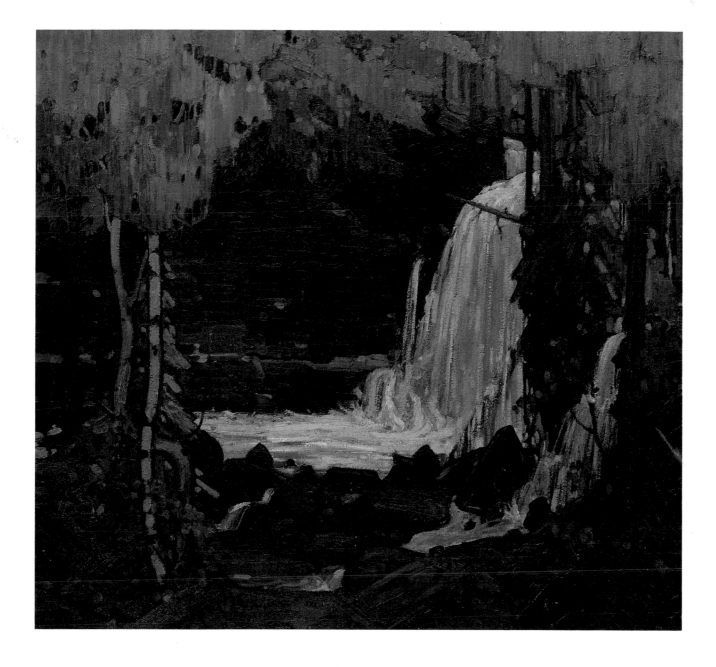

PLATE 35

TOM THOMSON

Woodland Waterfall, 1916-17

Oil on canvas

121.9 x 132.5 cm (48½ x 52⅛ in)

McMichael Canadian Art Collection, Kleinburg

Purchase with funds donated by the W. Garfield Weston Foundation, 1977

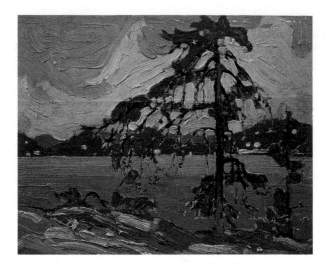

"Lift it up, bring it out," Thomson said of the way he developed a motif. We can understand what he meant if we compare the sketch which Thomson painted on Lake Cauchon in Algonquin Park with the painting done in the studio in Toronto. From the sketch he took the motif of the tree, down to its crimson undercoat, but he formalized and strengthened the design. He made the sky, water, and shoreline into bands of delicate, luminescent colour: they recall the radiance of stained glass and help evoke in the viewer the feeling that the scene witnessed is sacred.

As is evident in other paintings of this winter, Thomson was under the influence of Lawren Harris at this time. From Harris, Thomson took the almost square format of the canvas and broad handling, as well as the three-dimensional effect of the hills and foreground rocks.

Thomson used a vermilion undercoat in both the sketch and the canvas, as in The West Wind (Pl. 39). He left spaces around the branches so the red would vibrate. As he knew from his training in commercial art, the use of contrasting colours gives a dynamic effect: the foliage of the tree is outlined and enlivened by the use of blue paint. Viewers have spoken of its "living presence." Possibly Thomson was thinking of the tree as a living being in some ways: its shape recalls the figure of a person. As was true of other works of this season, Thomson was reportedly unhappy with what he achieved. He had trouble with the sky, Jackson said, and scraped the background a good deal. The narrow horizontal clouds recall an earlier painting, The Pointers (Pl. 25). He could have borrowed them from that source.

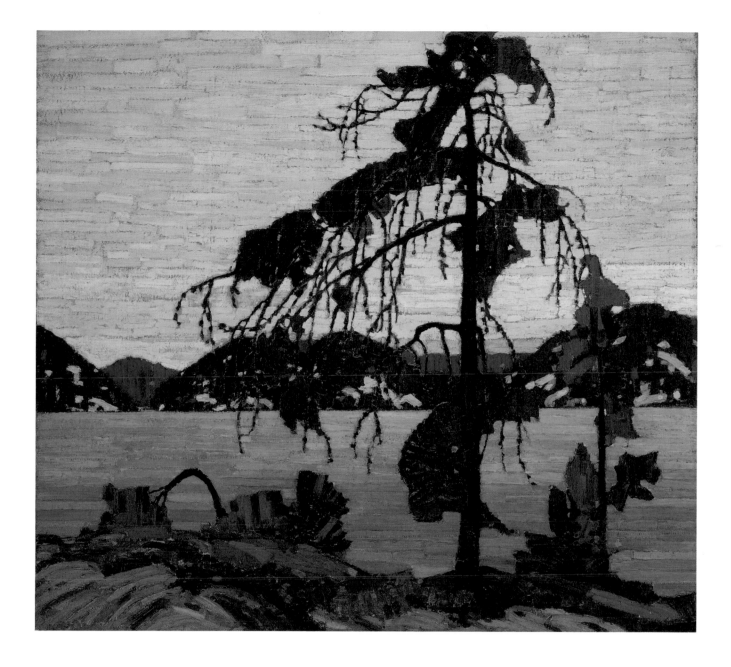

PLATE 37

TOM THOMSON

The Jack Pine, 1916-17

Oil on canvas

127.9 x 139.8 cm (50¼ x 55 in)

National Gallery of Canada, Ottawa

Purchase, 1918

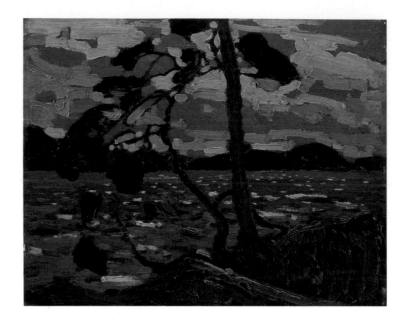

PLATE 38

TOM THOMSON

Sketch for *The West Wind*, 1916

Oil on panel
21.1 x 26.6 cm (8⁵⁄₁₆ x 10⁷⁄₁₆ in)
Art Gallery of Ontario, Toronto
Gift from the J.S. McLean Collection, Toronto, 1969;
donated by the Ontario Heritage Foundation, 1988

As in The Jack Pine *(Pl. 37), here Thomson lifted up and brought out the design qualities of a sketch of a tree he'd made that fall. There is no general consensus as to where the tree stood. A professor at the University of Toronto believed it was at Achray on Grand Lake, and in the 1950s provided the Art Gallery of Ontario with photographic "proof." Others believed the sketch was painted farther north, possibly in Pembroke. Thomson's girlfriend at the time, Winifred Trainor, believed it was painted at Cedar Lake.*

The painting today has the distinction of being one of the major icons of Canadian art. After Thomson's death, the painting exerted a powerful influence on the painters of his circle. The subject was painted by Lismer, Varley, Carmichael, and Casson. Some, including Arthur Lismer, have felt the tree is a symbol of the character of Canadians: pines which stand steadfast against the wind are emblematic of our resolute nature. Others such as Fred Housser, author of the first book on the Group of Seven, A Canadian Art Movement *(1926), compared the painting to poetry. "It is northern nature poetry," he said, "which could not have been created anywhere else in the world but in Canada." Lismer found poetry in the painting's imagery: the two trees are firmly set in the composition, one bent to a bow like the frame of a harp.*

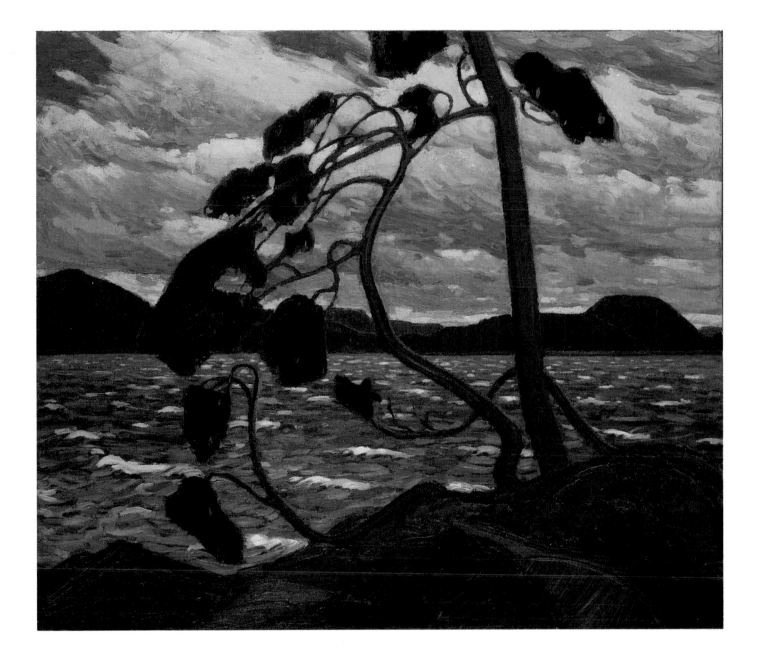

PLATE 39

TOM THOMSON

The West Wind, 1917

Oil on canvas
120.7 x 137.2 cm (47½ x 54 in)
Art Gallery of Ontario, Toronto
Gift of the Canadian Club of Toronto, 1926

PLATE 40

L A W R E N H A R R I S

Decorative Landscape, 1917

Oil on canvas

122.5 x 131.7 cm (48¼ x 51¾ in)

National Gallery of Canada, Ottawa

Purchase, 1992

This important canvas was purchased by a private collector in Toronto in the mid-1960s. When Charles Hill, the curator of the National Gallery of Canada, visited the painting's owner for another reason, he was astonished to see it, and entered into negotiations to purchase it for the National Gallery. We don't know of any preliminary sketches for this work, or where it was painted. Charles Hill says that Harris conceived the landscape as a sort of ideal to capture the northern experience in a decorative manner. In the work, Harris juxtaposed thick strokes of complementary hues, a technique he derived from the Swiss painter Giovanni Segantini that is sometimes called the "Segantini stitch."

When Harris showed the painting at the exhibit of the Ontario Society of Artists in March 1917, critic Hector Charlesworth wrote in Saturday Night *that the general effect was that of a garish poster. The critic for* The Mail and Empire *responded more favourably to its experiment with colour, but even he felt it was not Harris at his best. Today we appreciate the brilliant hues, especially the intense contrast of the bright yellow sky and the electric blue and green spruce trees. The glimpse through trees of the shoreline on the horizon is like a look at a promised land. The image is indelible.*

Harris's friend Fred Housser wrote in 1926 that, in 1917, Harris, whose brother Howard had been killed in action, was doing duty at army headquarters in Toronto, when the national spirit of the day provoked in him a desire to express what he felt about the country in a more creative and magnificent communion than that of war. "It must be on a grander scale than anything hitherto attempted, heroic enough to stir the national pulse when the stimulus of struggle had been withdrawn," said Housser, describing Harris's intent. Perhaps the painting's emphatic quality stems from this impulse. Shortly thereafter, Harris's health gave out and he suffered a nervous breakdown.

PLATE 41

TOM THOMSON

Northern Lights, 1916?

Oil on panel
21.6 x 26.7 cm (8½ x 10½ in)
Montreal Museum of Fine Arts
Gift of A. Sidney Dawes, 1947

Thomson's first nocturne was done in 1914; the subject became a favourite with him. To paint night scenes, he would stay inside Mowat Lodge, the hotel in Algonquin Park where he sometimes lived, then go out as often as he needed to check the scene. He loved the subtle colour harmonies of twilight, or here, the stunning effect of the northern lights.

One of these sketches was probably painted in 1916. In that year he used a goldenrod-coloured coat of paint to seal the surface of his wooden panel. The coat is visible beneath the painted surface of the sketch above.

From January to May 1917, Daphne Crombie stayed in Algonquin Park and, when Thomson arrived in April, enjoyed talking with him about his work. She recalled that, before her visit, he had painted a sketch of the northern lights with "a dark bar." Through the bar were streaks of light coming down, she said. The above sketch could be the one she described.

The oil-on-beaverwood sketch could be dated to 1917 since it has no stamp. It belonged to Thomson's friend Dr. MacCallum, who went on a fishing trip in Algonquin Park with Thomson in May 1917. Thomson probably gave it to him.

Thomson's sketches of the northern lights are among the most mysterious and transcendental of his career. Here, the hills appear to tremble in the eerie glow. In yet another version, owned by the Thomson family, the lights shoot into the sky like rays. The design in these works, though of great simplicity, is extremely effective. Thomson wrote his father shortly before he died that he had scraped a lot of his sketches — that is, used a palette knife to get old paint off — but he was painting more. The outline of another sketch — lost to the knife — is visible under the paint in the sketch at the right.

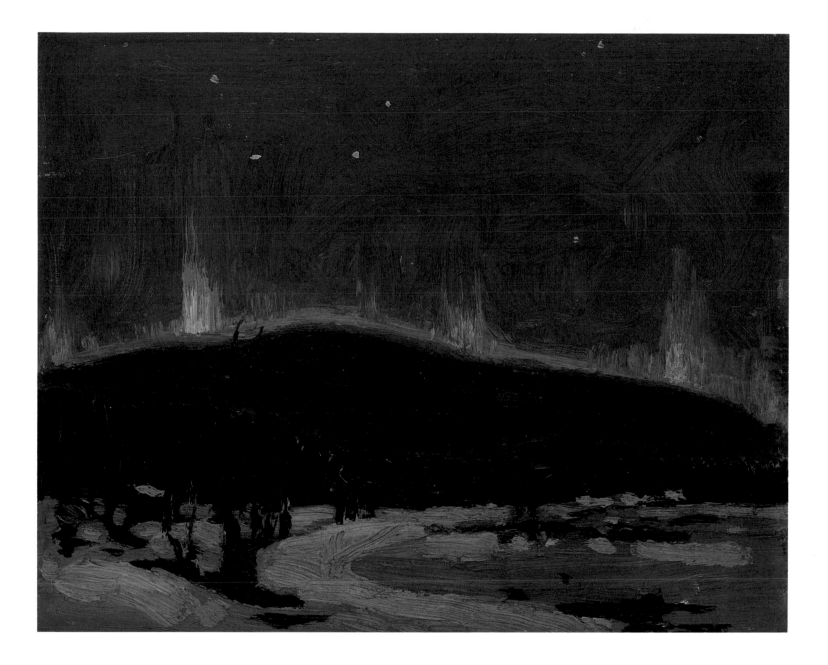

PLATE 42

TOM THOMSON

Northern Lights, 1917?

Oil on beaverboard
21.6 x 26.7 cm (8½ x 10½ in)
National Gallery of Canada, Ottawa
Bequest of Dr. J.M. MacCallum, Toronto, 1944

PLATE 43

ARTHUR LISMER

Mine Sweepers at Sea, 1917

Oil on board

30.4 x 40.7 cm (12 x 16 in)

Art Gallery of Nova Scotia, Halifax

Purchase, 1974

The paintings and lithographs of Halifax Harbour that Lismer made from 1917 to 1918 for the Canadian War Memorials are some of the best of his career. He imbued them with a sense of sweep and majesty, perhaps in celebration of his association with the exciting group that was being formed.

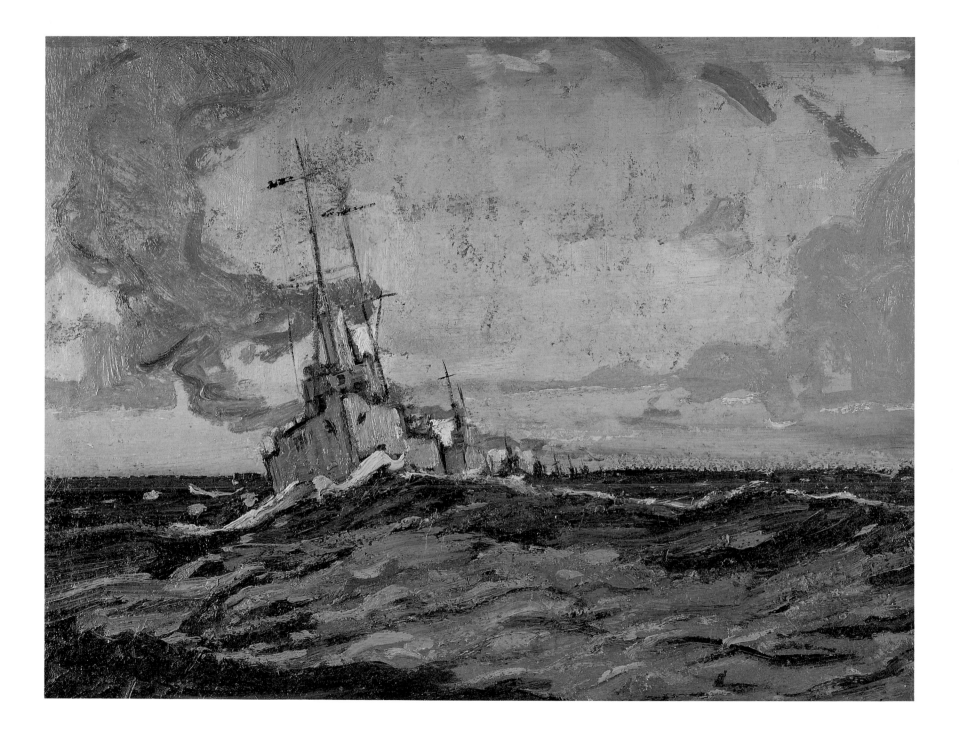

PLATE 44

F. H. VARLEY

The Sunken Road, 1919

Oil on canvas
132.4 x 162.8 cm (52⅛ x 64⅛ in)
Canadian War Museum, Ottawa

In 1919, Varley worked with the London office of Canadian War Records. This painting, a sad reminder of the anonymity of death on the battlefield, may have been started in England, but it was finished in Canada. Sunken roads result from long processes of erosion and the heaping of earth and debris along the hedgerows, stone walls, or pollards that line their sides. They are used in warfare because they provide such good, ready-made cover. Varley took the road from a sketch he'd made, and the figures of the dead, the remains of a German gun crew, from a photograph. The way the figures are painted — in the same colours as the rocks — reveals his view of the war. The rainbow that arches at left is a token of God's covenant from the biblical book of Genesis, Christopher Varley, the painter's grandson, has suggested. Varley used the rainbow ironically, as a symbol not of God's beneficence but of his wrath. The soldier who lies facing toward us at the centre of the painting has had the top of his head blown off.

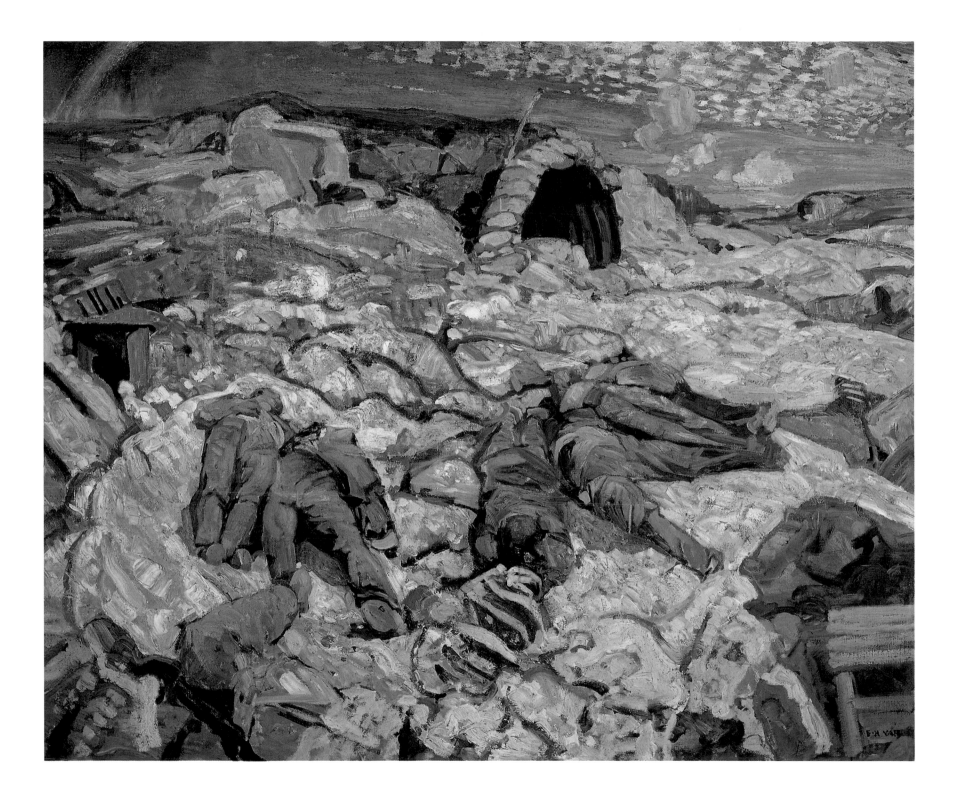

PLATE 45

J.E.H. MACDONALD

Sketch for *Leaves in the Brook*, c. 1918

Oil on pressed board
21.3 x 26.6 cm (8⅜ x 10⅜ in)
McMichael Canadian Art Collection, Kleinburg
Gift of A.Y. Jackson, 1966

MacDonald was interested in Oriental art, and may have been thinking of it for his composition as he painted Leaves in the Brook. *This source is suggested as a possibility when we look at the subtle conception of the autumn leaves falling into, and reflected in, the water; the dynamic composition; and the dark contour line which he used to denote the rocks and water. On the other hand, he could have taken the dark contour line from Vincent Van Gogh, whose work he much admired.*

The daring composition is typical of MacDonald. The viewer seems to be standing on a bank above the stream. As in Falls, Montreal River *(Pl. 54), MacDonald used a small* repoussoir *(a figure or object placed in the extreme foreground with the aim of deflecting the viewer's eye into the distance; here a rock with a leaf) to direct our gaze into the rollicking composition. The work is unusually joyous for MacDonald. He was clearly delighted by the play of colour and activity before him.*

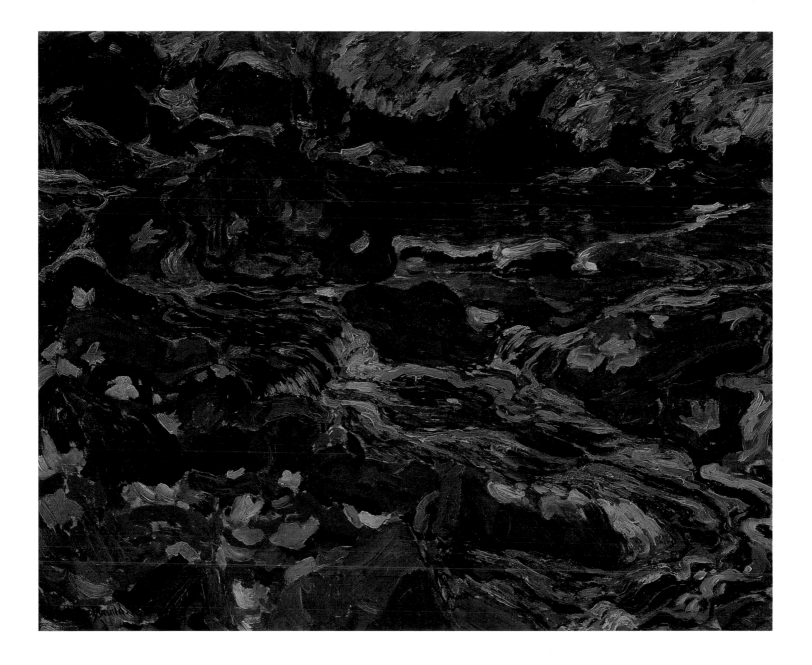

PLATE 46

J. E. H. MACDONALD

Leaves in the Brook, c. 1919

Oil on canvas

52.7 x 65.0 cm (20¾ x 25⅝ in)

McMichael Canadian Art Collection, Kleinburg

Gift of Dr. Arnold C. Mason, 1966

PLATE 47

LAWREN HARRIS

Winter Afternoon, City Street, Toronto (Sunday Morning), 1918

Oil on canvas
100.5 x 113 cm (39½ x 44½ in)
Ken Thomson, Toronto

Harris's urban subjects are among his most important themes and the paintings featuring them constitute some of his finest works. They were always popular. When they were originally shown, a reviewer in The Toronto Telegram *called a group of them "astonishing." He spoke of the quiet old houses with their charm of colour, and of how Harris had used such bright colour that the pictures shouted from the walls. Today these pictures still seem exhilarating and challenging; to us they are signs of the new direction in Canadian art. Winter Afternoon, City Street, Toronto (Sunday Morning) is bright and cheerful; Return from Church more sombre and solemn. Through this almost anecdotal (for Harris) subject, we gain an insight into life in Toronto at the time. His interest in the subject is also a reminder that his grandfather was a Presbyterian minister, and may have been his way of reinvestigating traditional values at a difficult moment in his life (his brother had been killed in the war).*

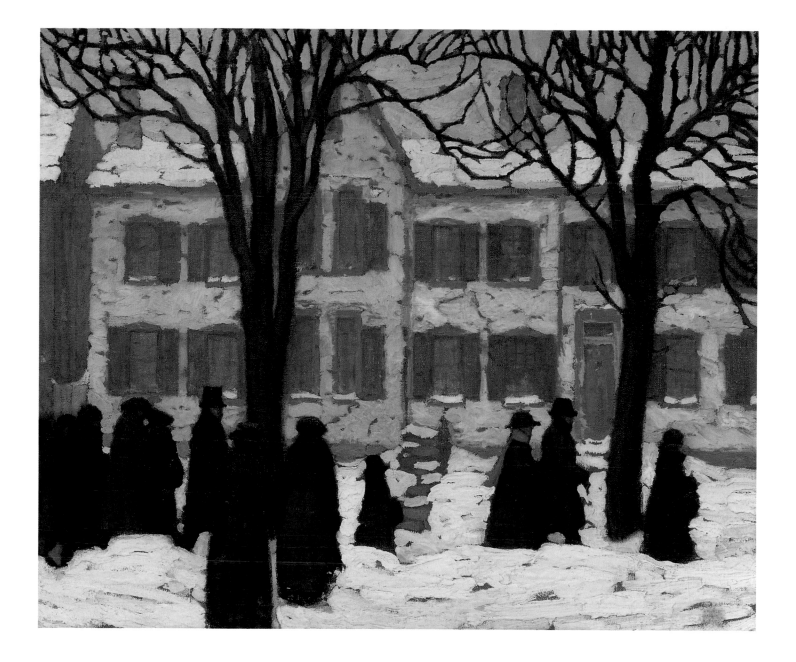

PLATE 48

LAWREN HARRIS

Return from Church, 1919

Oil on canvas
101.8 x 122.3 cm (40⅛ x 48⅛ in)
National Gallery of Canada, Ottawa
Gift of the artist, Vancouver, 1960

Harris's street scenes were painted in the downtown section of Toronto known as the Ward. Though the houses were working class, the area had warmth and colour. Harris used a heavy impasto in his paint, put on with a palette knife, in other works of the period. The house looks inhabited; the shade of the lower window at the left is drawn. The weather is cold and rainy. It is one of those days which mark the start of winter. The dreary mood of a subject Harris had previously often painted as happy was a reflection of his spirits at the time. Both Thomson and Harris's brother Howard had died in 1917, and the following year Harris had had a nervous breakdown. When he recovered, he painted this canvas. It was exhibited in the Ontario Society of Artists show of March 1919 as In the Ward II.

Despite the sombre mood, Harris paid careful attention to the composition. The trees and branches carefully frame the doorways and windows of the house; the work has a sense of volume and depth. He painted the reflections in the puddles of rain with masterly technique.

PLATE 50

A. Y. JACKSON

First Snow, Algoma, c. 1919-20

Oil on canvas
107.1 x 127.7 cm (42⅛ x 50¼ in)
McMichael Canadian Art Collection, Kleinburg
Gift in memory of Gertrude Wells Hilborn, 1966

Jackson's vision of Algoma was more airy and ethereal than MacDonald's; he painted the transfiguring power of the snow and the pattern it makes as it whirls over the land like a curtain blown by the wind. It frames the powerful diagonal rhythms of the autumn landscape. As in Terre Sauvage (Pl. 16), Jackson has focused on the individual shapes of the ragged trees and the tree stumps. We look down at the landscape from a rocky hilltop; the land flows in our direction, curbed by the powerful horizontal of background blue hills. Although the landscape has depth and the trees are three-dimensional, Jackson used the snow to create a decorative screen so that we seem to look more at legend than at reality.

It is possible that Jackson, who had learned about Impressionism in France, knew Monet's Snow at Argenteuil I (1874, Museum of Fine Arts, Boston). The impression of the swirling curtain of snow seems similar. Yet Jackson makes the screen of snow his own; in his hands there is not only drama but gaiety. That this is a picture which Jackson planned as a statement is clear: he wanted to demonstrate to his friends in the newly forming Group of Seven what he could do.

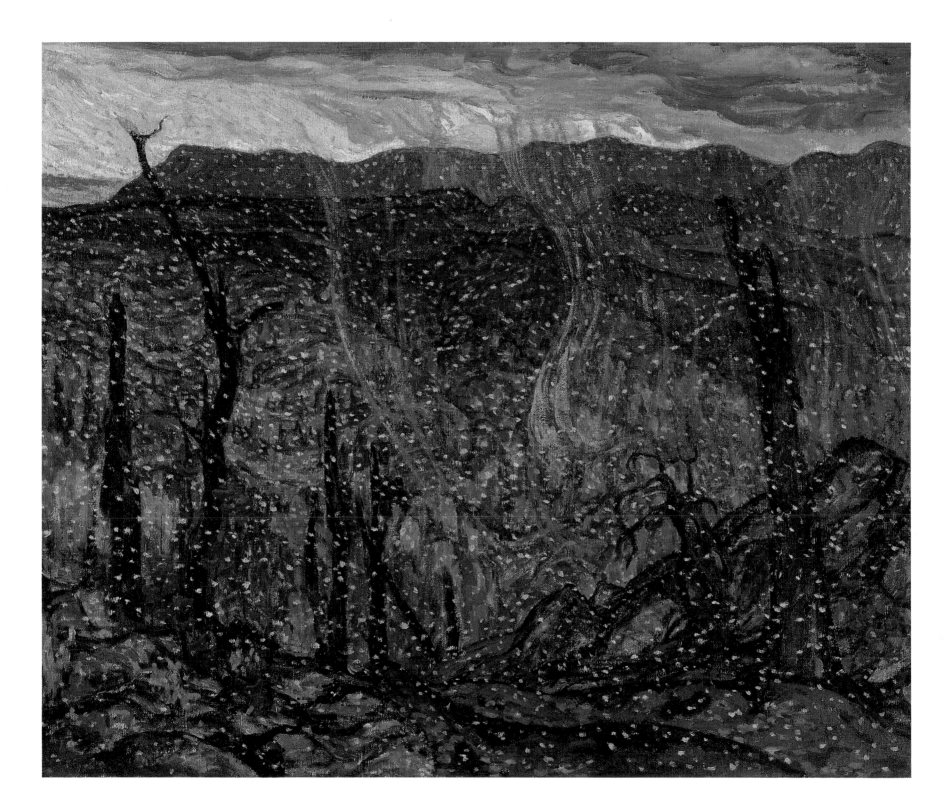

PLATE 51

FRANK H. (FRANZ) JOHNSTON

Fire-Swept, Algoma, 1920

Oil on canvas
127.5 x 167.5 cm (50¼ x 66 in)
National Gallery of Canada, Ottawa
Purchase, 1920

Johnston's enthusiasm for the newly formed Group of Seven was shown by his wholehearted participation in their first exhibition: he had more paintings on show than any other member. The dimensions of Fire-Swept, Algoma, *its panoramic view, and bold handling also reveal his sympathy with the ideals of the Group. (The elevated view was also used by Jackson in* First Snow, Algoma *[Pl. 50], and MacDonald in* The Solemn Land *[Pl. 59].) Like MacDonald in* Falls, Montreal River *(Pl. 54), he treated the distance as a stage-set backdrop. His move to Winnipeg in 1920 to become principal of the School of Art and the direction of his art toward a more atmospheric handling and modulated portrayal understandably separated him from the Group.*

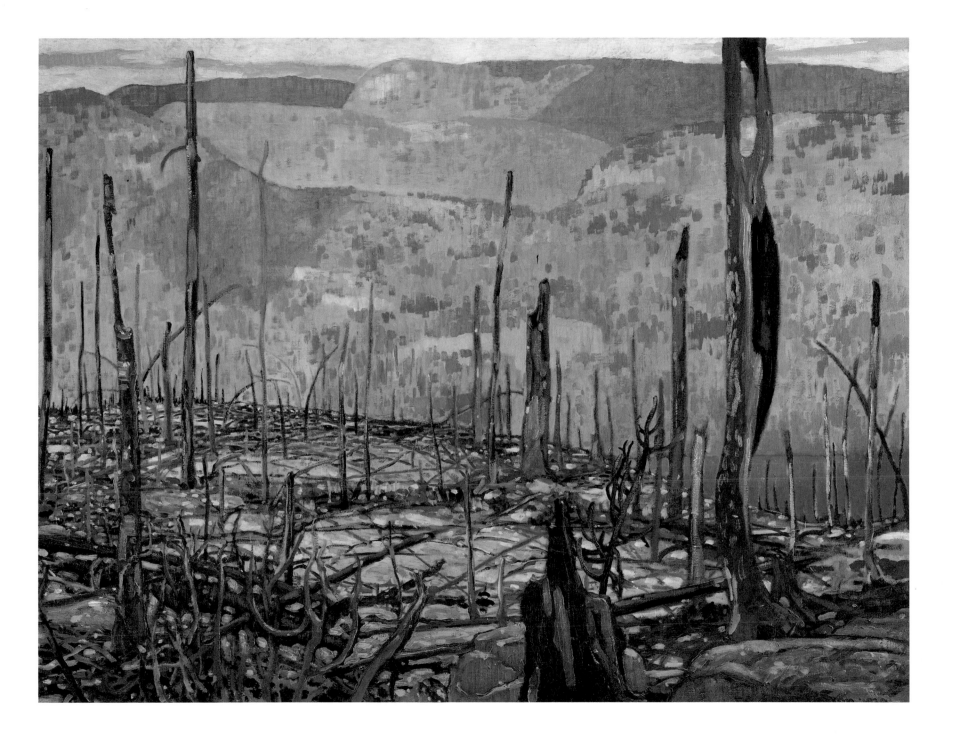

PLATE 52

LAWREN HARRIS

Beaver Swamp, Algoma, 1920

Oil on canvas
120.7 x 141.0 cm (47½ x 55½ in)
Art Gallery of Ontario, Toronto
Gift of Ruth Massey Tovell in memory of Harold Murchison Tovell, 1953

Harris spoke of the wild richness and clarity of colour he found in the Algoma woods, but it was not "his" country, as Lake Superior was. Jackson said the Algoma wilderness was too opulent for him. When he did paint it successfully, as here, he treated it as he did Lake Superior, reducing the forms to strong shapes and using simple compositions.

In painting this beaver swamp, he would have thought of Thomson's Northern River *(Pl. 21), which partially explains the echo of Thomson's darkened screen of trees and interwoven branches. Harris's picture is also of the woods at night, a sort of "Evening Solitude," as he titled another of his Algoma oils. Here the sun sets on a silent scene. The way Harris painted the screen recalls another idea of Thomson's, one from* The Jack Pine *(Pl. 37) — there is a dark red undercoat of pigment. Probably Harris was still grieving over Thomson's death.*

Art historian Jeremy Adamson wrote that "the looming, dark skeletal shapes of the trees produces an eerie quality which is intensified by the spectral glow of light that floods the evening sky."

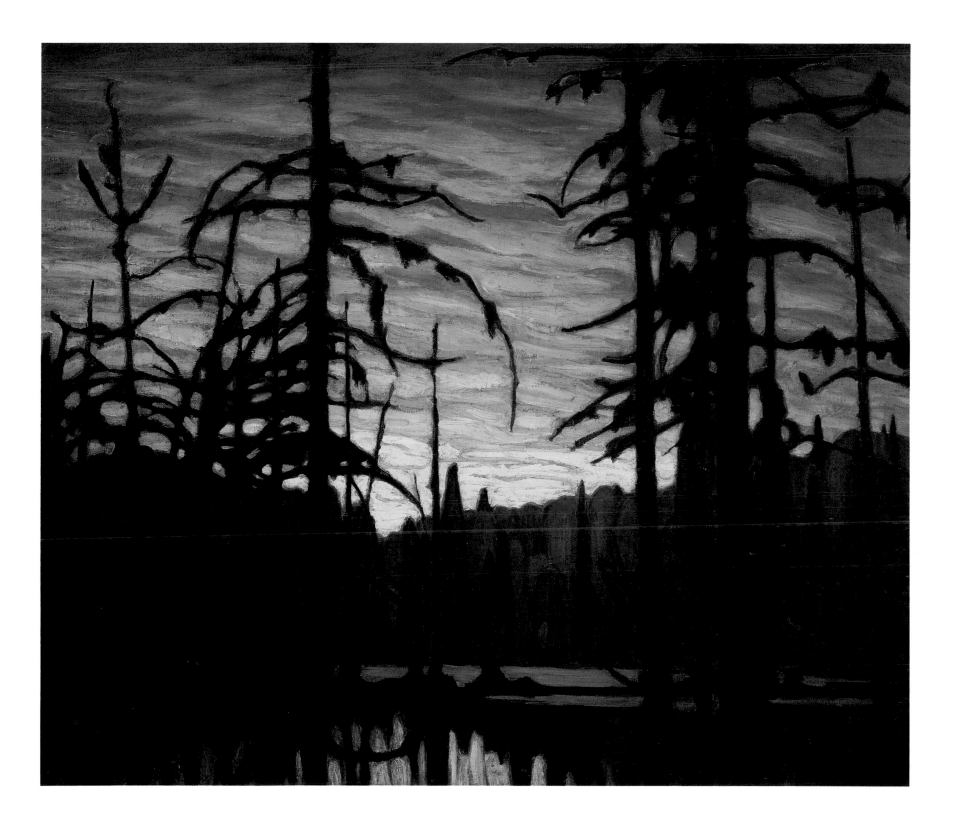

PLATE 53

FRANKLIN CARMICHAEL

Autumn Hillside, 1920

Oil on canvas

76.0 x 91.4 cm (30 x 36 in)

Art Gallery of Ontario, Toronto

Gift from the J.S. McLean Collection, 1969, donated by the Ontario Heritage Foundation, 1988

Jackson used the word "lyrical" to describe Carmichael's paintings of trees in the first exhibition of the Group of Seven, in which this work was shown. The canvas is so cheerful that we may feel the scene before us springs from some sort of fairy tale. In the foreground are a tree stump and purple and brown rocks; in the middle ground, pine trees which gather like regal Victorian ladies; and in the background, the yellow, orange, cream, and yellow-green foliage of birches. In the far distance, a curtain of cloud cuts off our view of clear sky. The motif of the lifted cloud bank, a commonplace of Victorian Canadian art, often appears in Carmichael's work.

Note the crowded, tree-strewn foreground. The trunks create a repoussoir; *it is a device typical of MacDonald. Carmichael's able design skills are shown by the strong, idiosyncratically shaped, three-dimensional pine trees.*

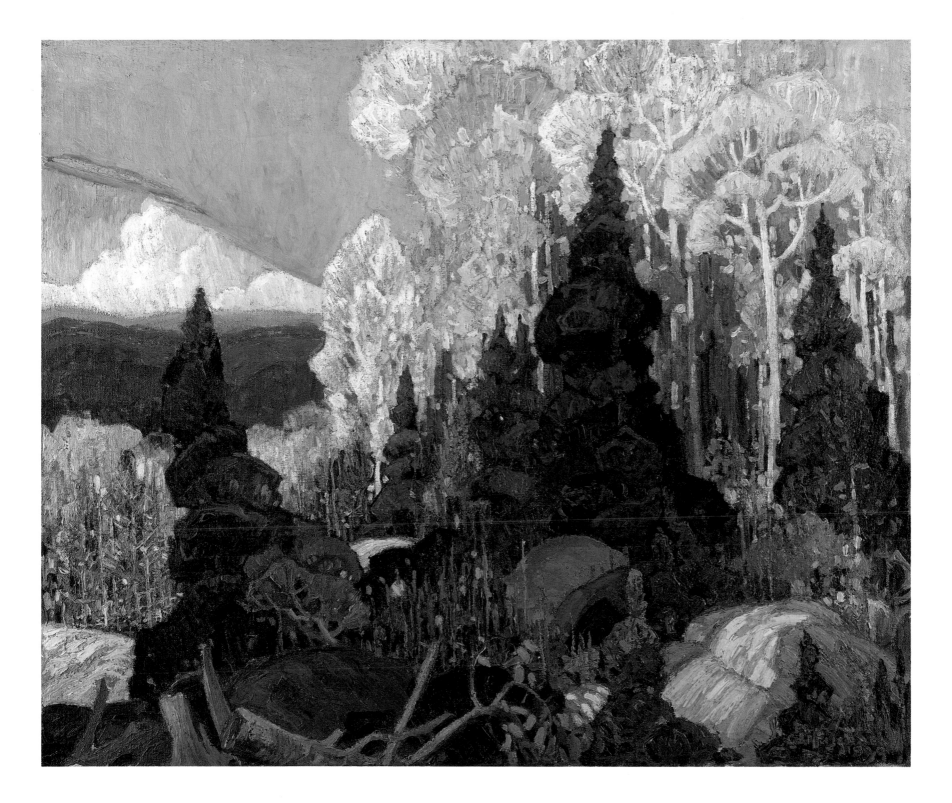

PLATE 54

J. E. H. M A C D O N A L D

Falls, Montreal River, 1920

Oil on canvas
121.9 x 153.0 (48 x 60¼ in)
Art Gallery of Ontario, Toronto
Purchase, 1933

J.E.H. MacDonald was one of the great designers in the history of Canadian art. His works, because of their riveting compositions, remain in the viewers' memory long after others are forgotten. This painting is an example of MacDonald's work at the height of his powers: the swirling water zigzags to distant curves which are echoed in the far-away hills. All nature seems in unity. The odd, complex, often hot colours MacDonald loved appear: olive greens and coral pinks, gold and turquoise. A red branch in the centre of the foreground, which seems to spring from the viewer's world, helps to push the scene before us back into the picture space, as well as pointing our eye in the intended direction.

The tumbling, rapidly flowing water is an appropriate image for the energy of the Group of Seven, which was founded in the year this work was completed.

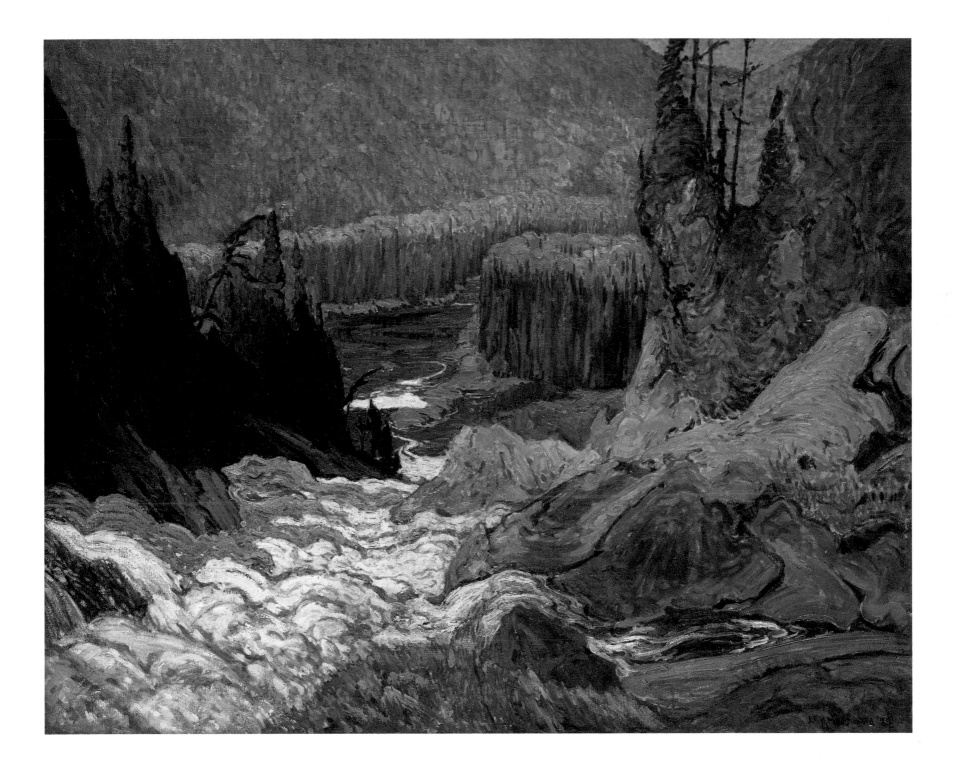

PLATE 55

A. Y. JACKSON

Lake Cognashene, 1920

Oil on canvas

63.5 x 81.3 cm. (25 x 32 in)

Art Gallery of Windsor

Gift of Edmond G. and Gloria Odette, 1976

Jackson had a special affinity for the Georgian Bay area: he loved the shapes of the clouds, the wind-swept trees, and the rocky islands. He called the Georgian Bay area in Muskoka one of his "'happy hunting-grounds' for camping and fishing at all seasons, and in all kinds of weather." In February 1920, he went to Franceville, and stayed there, travelling by snowshoe to find material to paint. As the weather grew milder, the ice melted, and open water appeared. When he got back to Toronto, the first thing he heard was that the Group of Seven had been formed, and that he was a member. He then painted several canvases from his sketches, with the idea in mind of making a strong statement. In this work, the contrast of pinks and soft reds recalls European art, especially certain works Jackson would have known of by various Impressionists and Post-Impressionists, perhaps Renoir or Van Gogh, both of whom he admired.

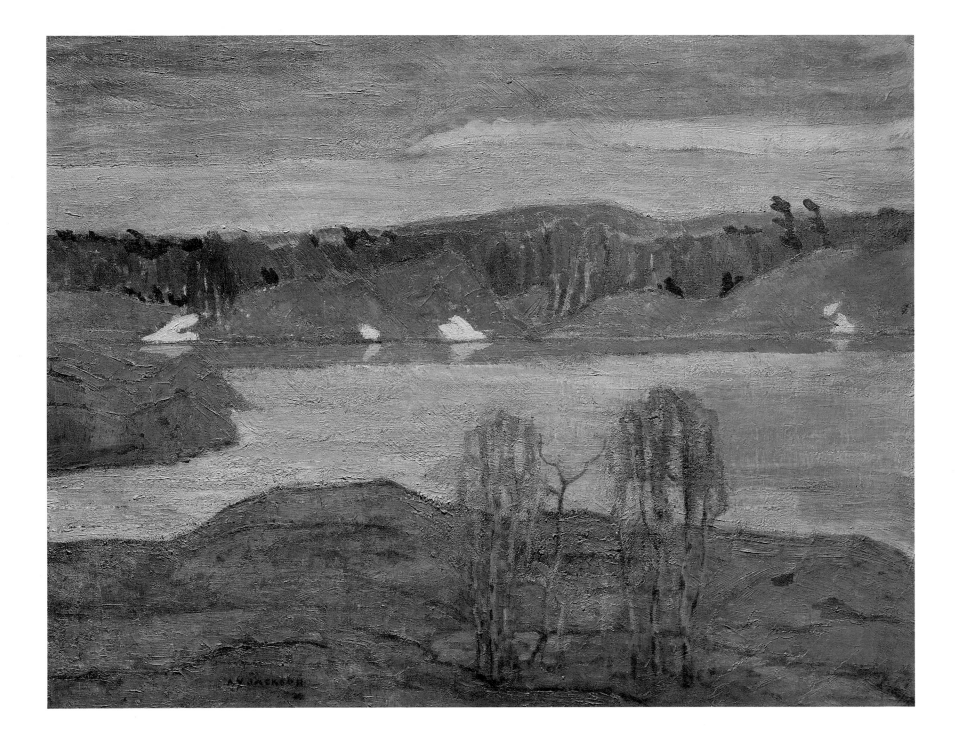

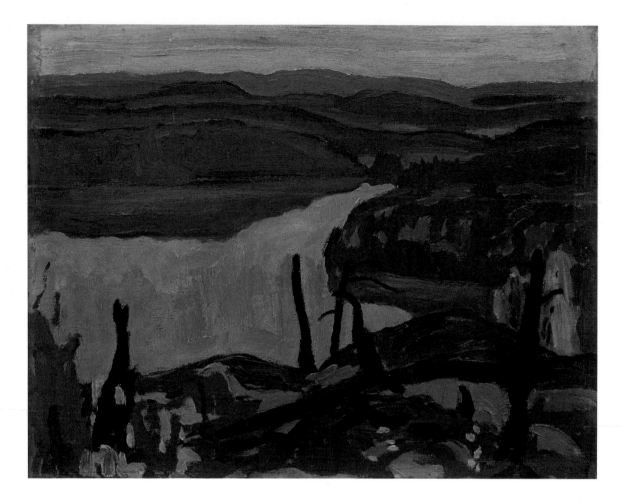

PLATE 56

A. Y. JACKSON

Wartz Lake, Algoma, 1920

Oil on panel
20.9 x 26.4 cm (8³⁄₁₆ x 10³⁄₈ in)
Vancouver Art Gallery
Gift of Mr. and Mrs. Lawren Harris, 1951

Lawren Harris called October Morning, Algoma *one of the finest of Jackson's large canvases. In 1926 a critic, reviewing the show at the University of Toronto's Hart House in which Jackson exhibited* October Morning, Algoma, *called the painting more typical of Harris. Its sense of vista in some ways does recall Harris's* Above Lake Superior *(Pl. 79). The sweeping horizontal rhythms of the distant hills are characteristic of Jackson, however, as are the fiery reds and tapestry-like effect. Art historian Russell Harper used to say that Jackson's predilection for such sweeping lines came from painting the snowy landscape of his native Quebec.*

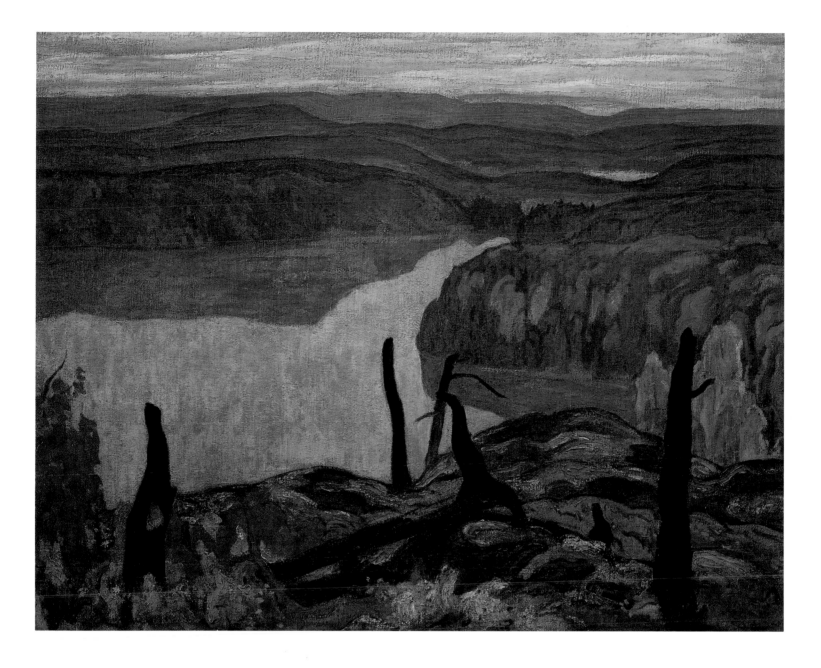

PLATE 57

A. Y. JACKSON

October Morning, Algoma (Wartz Lake, Algoma), 1920

Oil on canvas

52.0 x 60.0 cm (20½ x 23⅝ in)

Hart House Collection, University of Toronto

Purchase by the House Committee, 1931-32

PLATE 58

F. H. VARLEY

John, C. 1920-21

Oil on canvas

61.7 x 51 cm (24¼ x 20⅛ in)

National Gallery of Canada, Ottawa

Purchase, 1921

Varley's painting of John (1912 - 1969), the eldest of his three sons, has freshness and audacity: the paint handling is deft. John's face is modelled in terms of the angular cheekbones, turned-up nose, dimples, and rounded chin. The painting's feeling of immediacy comes from the subject's tousled hair and gentle smile. He looks at his father trustingly, drawing himself up as though to say "Yes, Dad." Yet the shadow over his left eye makes him look somehow troubled.

Varley's love for John was deeply felt. In this portrait, he underlined his subject's innocence and angelic quality by making the background curtain look like curving columns of light. The light source is directly in front of him: we wonder if it is firelight. John looks warm, flushed, and very relaxed, as one does when seated before a fire.

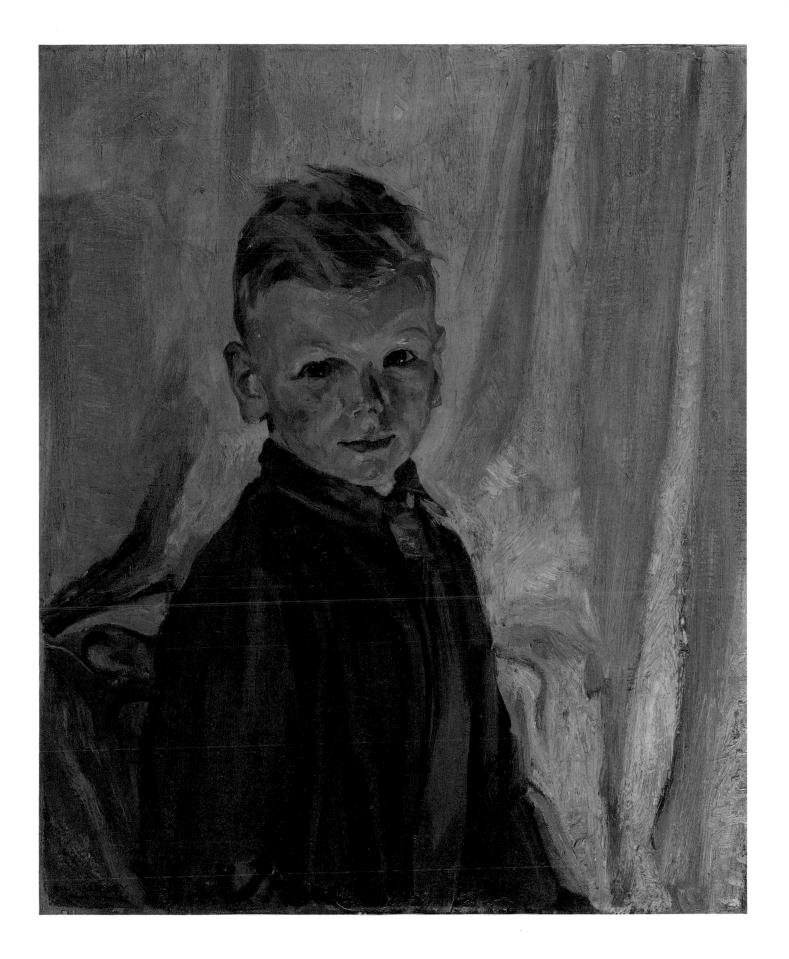

PLATE 59

J. E. H. MACDONALD

The Solemn Land, 1921

Oil on canvas

122.5 x 153.5 cm (48¼ x 60⅜ in)

National Gallery of Canada, Ottawa

Purchase, 1921

The Solemn Land *has seemed to many to be the most important canvas in MacDonald's* oeuvre; *others find it less exciting than works with more colour and movement. MacDonald may have meant the flatness of the design in the finished work to be a distant reference to Oriental art, which he loved. He firmly led the viewer's eye to depth in a path through the water: MacDonald knew how to use design powerfully. As in other works, a* repoussoir *(here the foliage of a red tree) creates a place for the viewer's eye to focus, then points to depth. In some ways it recalls the strong colours, bold design, and firm handling of the French Fauves. MacDonald would have been familiar with their use of hot rich colours.*

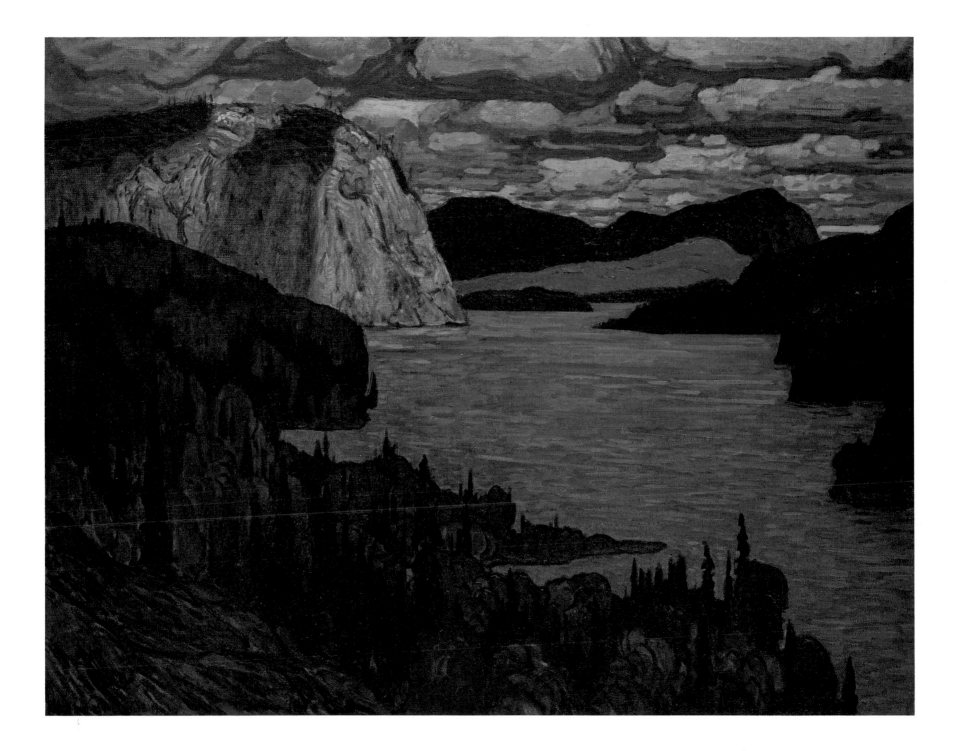

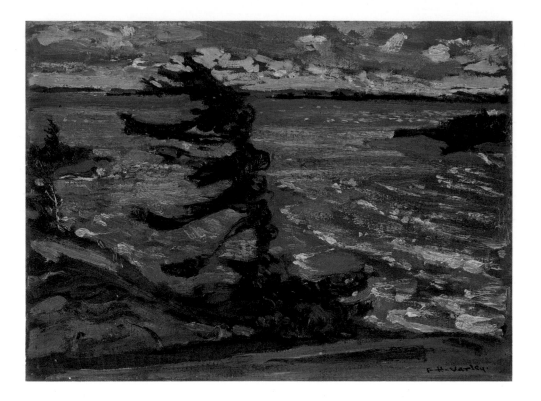

PLATE 60

F.H. VARLEY

Squally Weather, Georgian Bay, 1920

Oil on panel

29.8 x 41.2 cm (11¾ x 16¼ in)

National Gallery of Canada, Ottawa

Gift from Mrs. S.J. Williams, Mrs. Harvey Sims, Mrs. T.R. Cram,

and Miss Geneva Jackson, Kitchener, Ontario, 1943

Varley only rarely painted landscapes; his interest was in portraiture. Stormy Weather, Georgian Bay, *one of his most famous, is one of his few treatments of landscape. He apparently rose to the subject because of the influence of the formation of the Group of Seven in 1920, and he worked on the canvas over a period of time. He had been friendly with Thomson, with whom he had worked at the commercial design firms of Grip, then Rous and Mann, and deliberately evoked Thomson's image of a tree against a rocky shore. He developed the sketch (above) during squally weather in Georgian Bay, and used it as a basis for the canvas. It was painted near Dr. MacCallum's cottage at Go Home Bay, Georgian Bay. In it, he goes one step beyond Thomson in the feeling of windy weather; the rolling waves of water are also well understood. Unlike* The West Wind *(Pl. 39), where the viewer seems to look between the tree trunks toward the sky, here Varley looked down upon his tree, which seems to grow on a small piece of land between the rocks. Clearly he painted from a height.*

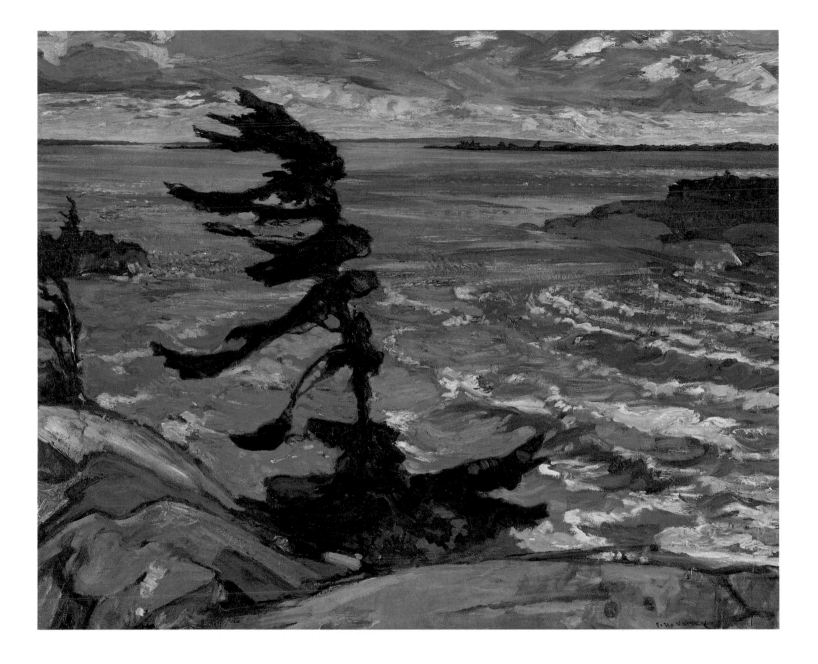

PLATE 61

F. H. VARLEY

Stormy Weather, Georgian Bay, c. 1920

Oil on canvas
132.6 x 162.8 cm (52¼ x 64⅛ in)
National Gallery of Canada, Ottawa
Purchase, 1921

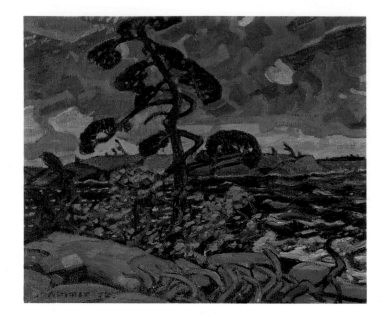

PLATE 62

ARTHUR LISMER

Study for *A September Gale, Georgian Bay*, 1920

Oil on canvas
51.5 x 61.0 cm (20¼ x 24 in)
National Gallery of Canada, Ottawa
Vincent Massey bequest, 1968

Lismer and Varley visited Georgian Bay together in the fall of 1920. Both developed sketches painted during the onset of a storm into major canvases. It appears that the artists stood about one hundred feet apart. Varley saw open water in the distance (see Pl. 61); Lismer, islands. They seem to have looked at different trees, and they painted them very distinctly. Varley's pine branches whipped by the wind recall a woman's garments; Lismer's are more three-dimensional. Of the two canvases, Lismer's is said to be greater. He had learned how to move close in, rendering his forms as so many sculptured shapes to capture the effect of the weather. His treatment of the rocks is more powerful and three-dimensional; he stressed their sides, and his sky has more atmosphere. He sought a strong design (note how he switched the direction of the wind in the final painting — his design background would have made this an easy task) and balanced it with a bolder, more Fauvist handling; Varley showed more of the landscape and responded to the scene by using a subdued Impressionistic style. We can see the difference if we look at the treatment of the water in the two works: whereas Lismer's waves literally rise out of the water, Varley's are more foamy. Both Lismer and Varley were thinking of Thomson at this moment. He had loved the drama of the storm and often painted it, as in The West Wind *(Pl. 39), which provided a model for later painters. Both of these canvases are larger than his, yet neither has the impact of the intricate, interlocking pattern of his pine trees in* The West Wind.

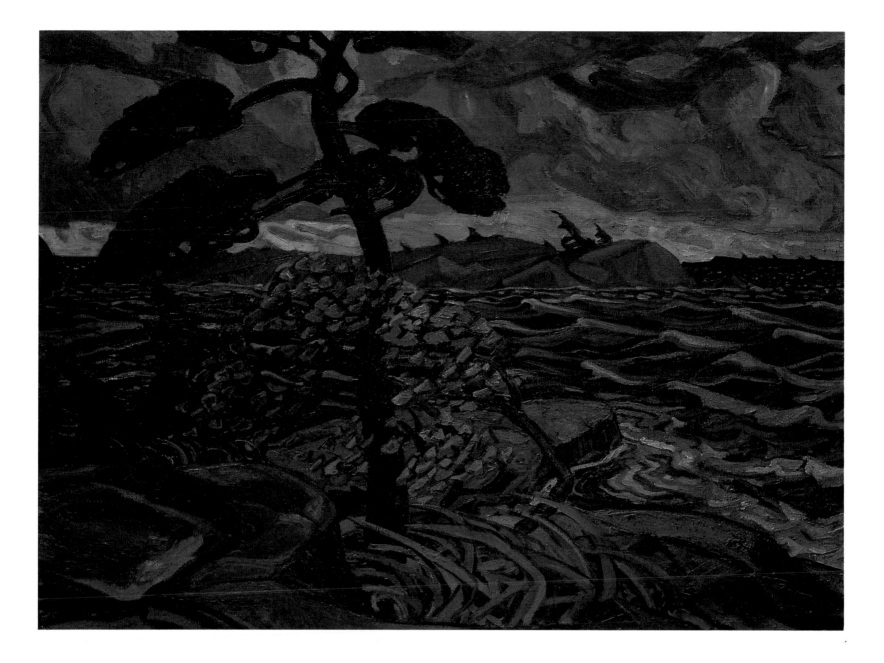

PLATE 63

ARTHUR LISMER

A September Gale, Georgian Bay, 1921

Oil on canvas

122.4 x 163.0 cm (48¼ x 64¼ in)

National Gallery of Canada, Ottawa

Purchase, 1926

PLATE 64

LAWREN HARRIS

Elevator Court, Halifax, 1921

Oil on canvas

96.5 x 112.1 cm (38 x 44⅛ in)

Art Gallery of Ontario, Toronto

Gift from the Albert H. Robson Memorial Subscription Fund, 1941

In the spring of 1921, Harris travelled to the East Coast to visit Nova Scotia and Newfoundland. In Halifax he discovered wooden clapboard tenements off Barrington Street, near the harbour. The structures fascinated him: they seemed to express the spiritual simplicity of the people who lived in them.

In painting them, he seems to have intended some form of social comment. When these canvases were first exhibited, viewers spoke of their bitter note. Some thought they represented a cry for change. Yet the scene is cleansed and simplified down to essentials. The light in the sky, and on the houses and snow, suggests a new age dawning: the harmony of the yellow clouds in the background with the blue sky and blue snow in the foreground gives a poetic quality to the boxy houses.

A yellow-blue polarity had a mystical significance for Theosophists, the group of which Harris was a member. Yellow was said to represent intelligence; blue, religious feeling. Harris may have had these equivalences in mind as he painted.

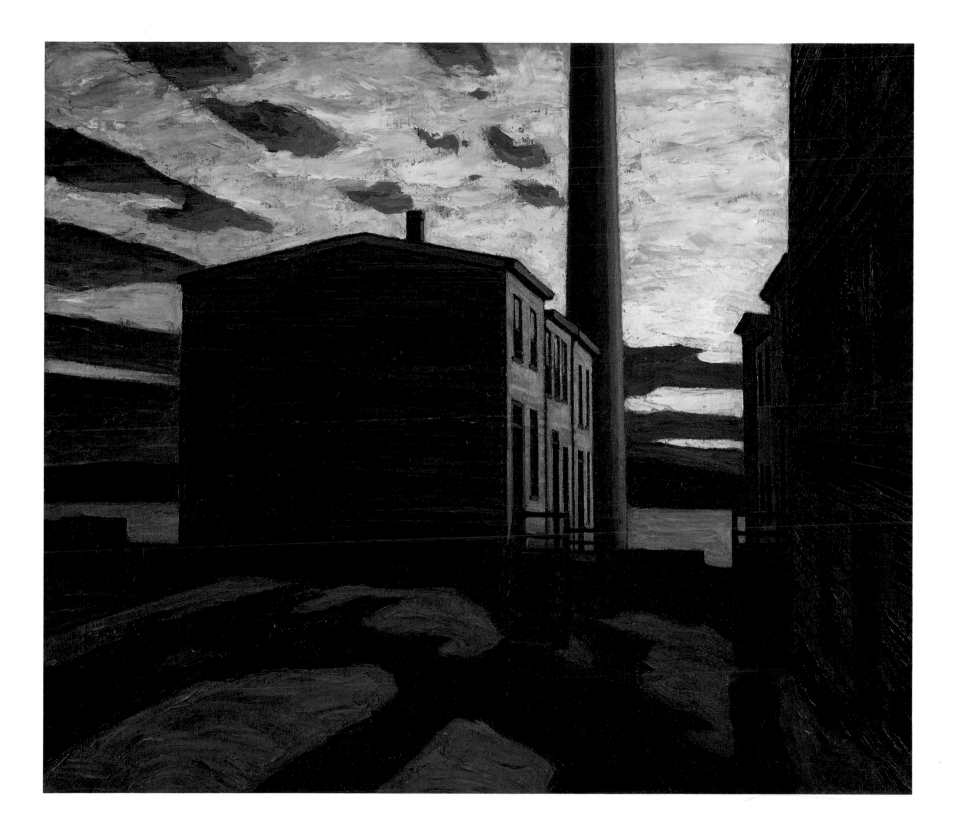

PLATE 65

FRANKLIN CARMICHAEL

Silvery Tangle, 1921

Oil on canvas

101.6 x 119.7 cm (40 x 47⅛ in)

Art Gallery of Ontario, Toronto

Gift from the Albert H. Robson Memorial Subscription Fund, 1947

Silvery Tangle is not often reproduced in the mass of material about the Group of Seven: modern taste favours works which are stronger in colouring. Yet the silvery tone of the underbrush and trees is handsomely depicted here.

From December 1914 until April 1915, Carmichael had shared a studio with Thomson; they became such good friends that Carmichael joked they had got married. That winter, Thomson painted Northern River *(Pl. 21), which has a rich, tangled effect of branches and trees. Carmichael may have thought of Thomson's great painting as he worked on* Silvery Tangle. *There are other suggestions of Thomson, for example, in the motif of the trees which cross each other at right. Carmichael's delicate, subtle use of colour is his own, however.*

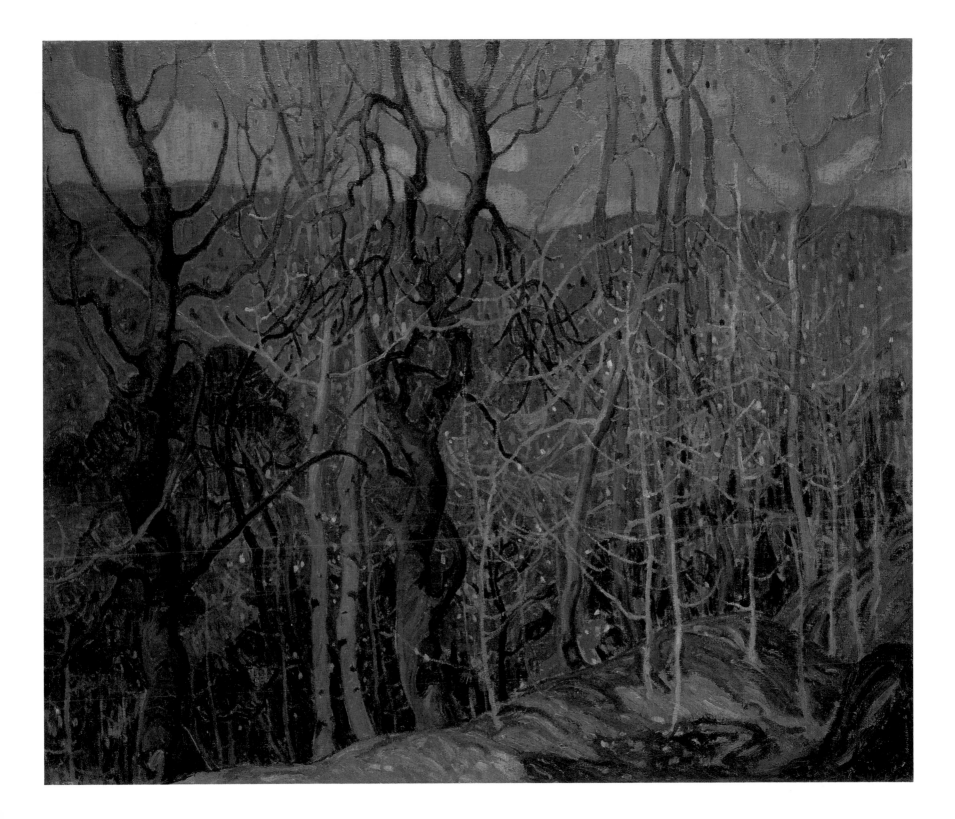

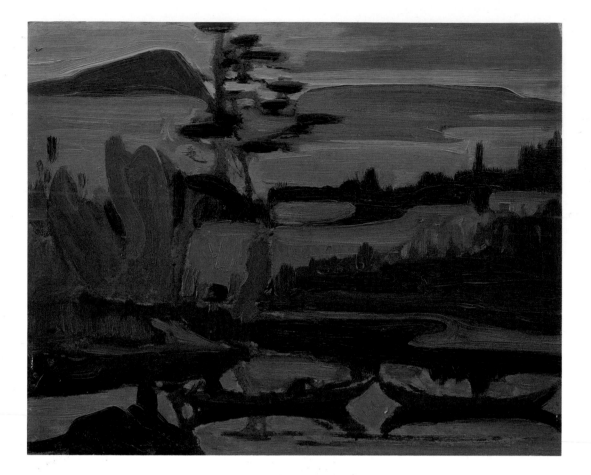

PLATE 66

J. E. H. MACDONALD

Mist Fantasy, Sand River, Algoma, 1920

Oil on cardboard
21.4 x 26.6 cm (8⁷⁄₁₆ x 10⁷⁄₁₆ in)
National Gallery of Canada, Ottawa
Purchase, 1947

Lawren Harris said that MacDonald did his best work in Algoma: this painting was done from a sketch made on the Sand River. If we compare the sketch with the canvas, we can see that MacDonald made many changes. Like Thomson, he believed in emphasizing what was only implied in the sketch. The wavy ribbons of mist are additions, as are the trees on the opposite shore. The mood is different as well. From being a muted, intimate notation, it has become a stylized statement on a theme of the North, one with Art Nouveau qualities. One scholar, Nancy Robertson Dillow, wrote in 1965 that, in Mist Fantasy, Northland, *MacDonald moved toward abstraction. The comment is true of the sketch.*

PLATE 67

J. E. H. MACDONALD

Mist Fantasy, Northland, 1922

Oil on canvas
53.7 x 66.7 cm (21⅛ x 26¼ in)
Art Gallery of Ontario, Toronto
Gift of S.J. Williams in memory of F. Elinor Williams, 1927

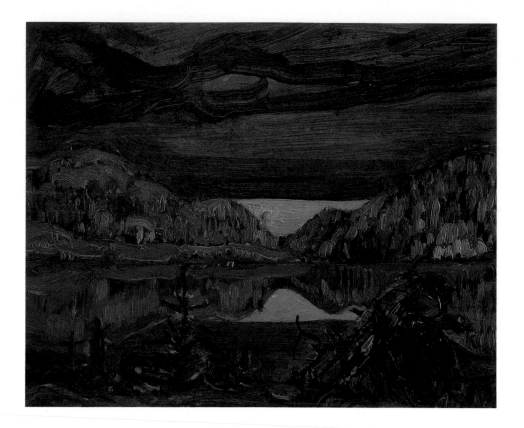

PLATE 68

J.E.H. MACDONALD

Sketch for *October Shower Gleam*, 1920

Oil on board
21.5 x 26 cm (8¼ x 10¼ in)
Ken Thomson, Toronto

In the autumn of 1920, Lawren Harris arranged a sketching party in Algoma and had a boxcar fitted with bunks and a stove to accommodate Group members. It was hitched to a passenger or freight train. When they reached a place where they wished to paint, the boxcar was left on a siding and became a studio. In 1920 the party consisted of Harris, Jackson, MacDonald, and Frank Johnston. On this trip MacDonald made studies for October Shower Gleam, and Jackson got the sketch that he later painted into a large canvas, October Morning, Algoma (Pl. 57).

This painting is one of MacDonald's most peaceful and tranquil. As is usual in MacDonald's work, the viewer's eye is led over a repoussoir (here, a group of pine trees and stumps) to the colourful hills, and then to the turbulent sky. The painting works in a series of reflections. The dark clouds are reflected in the foreground, the lighter hills in the water. The moment he chose is that of the calm before the storm.

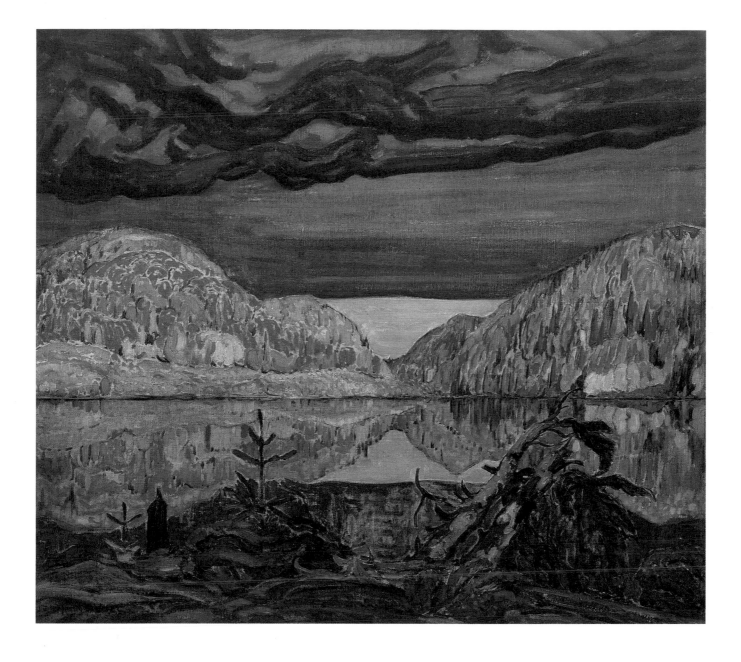

PLATE 69

J. E. H. MACDONALD

October Shower Gleam, 1922

Oil on canvas
105.4 x 120.7 cm (41½ x 47½ in)
Hart House Collection, University of Toronto
Purchased with income from the Harold and Murray Wrong Memorial Fund, 1933

PLATE 70

J. E. H. MACDONALD

Rowanberries (Mountain Ash), Algoma, 1922

Oil on canvas

76.2 x 88.9 cm (30 x 35 in)

Ken Thomson, Toronto

MacDonald's depiction of a branch of berries lying across the surface of the painting, through which the viewer looks to see a flowing stream, is practically unique in the sustained power of its inspiration. A fan of Van Gogh, MacDonald seems to have drawn upon the Dutch painter's bold strokes and dark contour lines to outline forms for certain details of the work, particularly the foreground, as writer Paul Duval has pointed out.

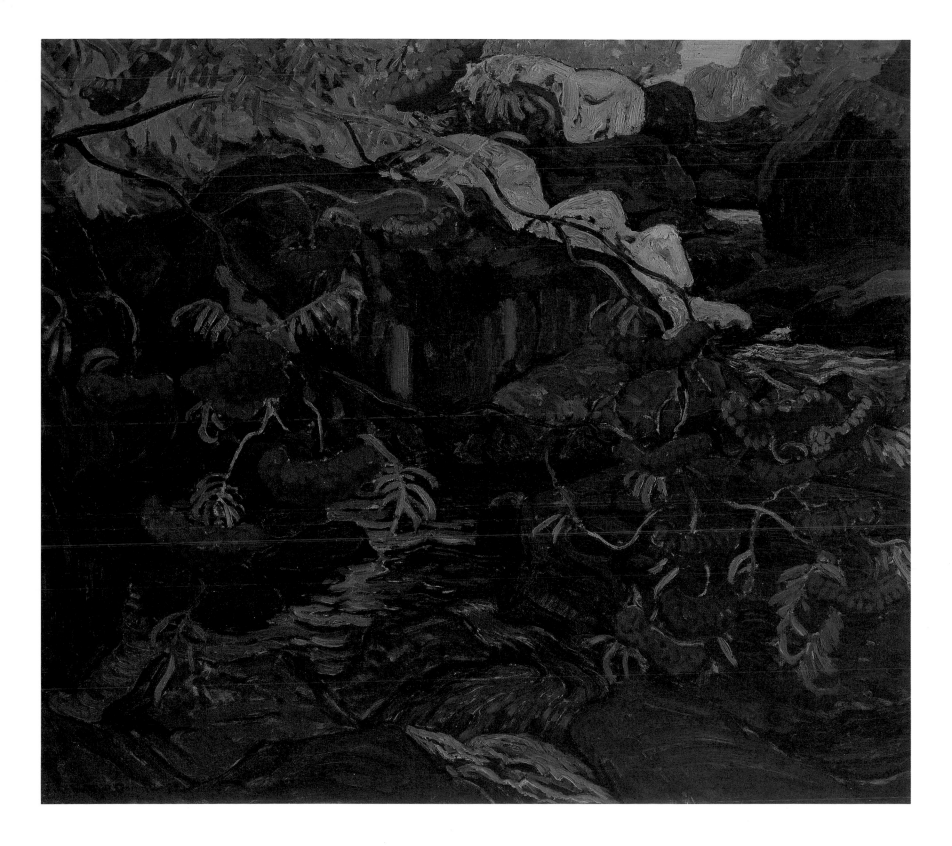

PLATE 7 1

FRANK H. (FRANZ) JOHNSTON

Serenity, Lake of the Woods, 1922

Oil on canvas
102.3 x 128.4 cm (40¼ x 50½ in)
Winnipeg Art Gallery

Frank H. (Franz) Johnston was a founding member of the Group, but he showed only in the first exhibit. He then left for the west, where he became principal of the School of Art in Winnipeg. In fact, his work was more oriented to the turn-of-the-century atmospheric painters of Canada. Yet the large area of the canvas given to the clouds expresses the spirit of this part of the country, a thoroughly Group idea.

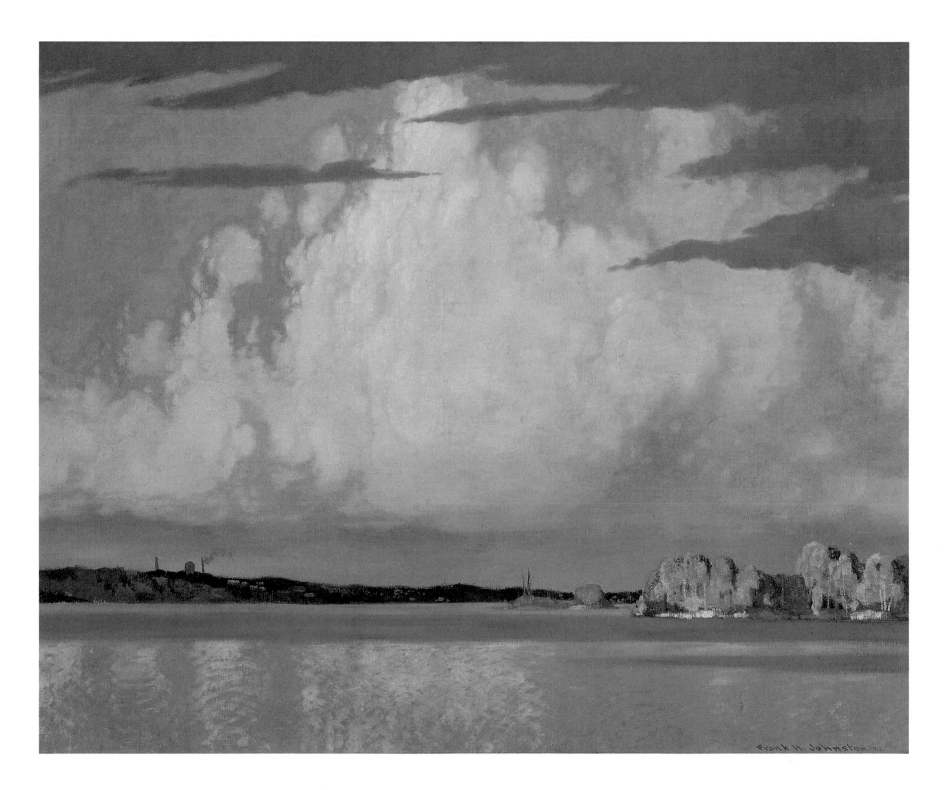

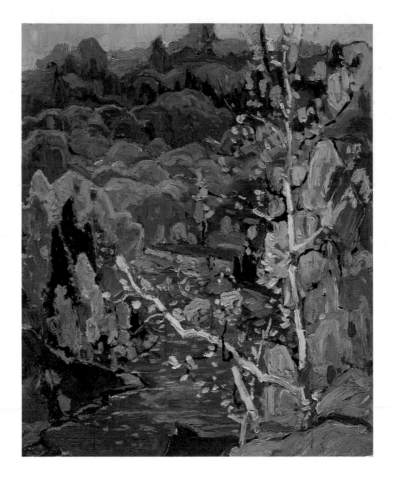

PLATE 72

FRANKLIN CARMICHAEL

Lansing (sketch for *October Gold*), c. 1921

Oil on panel
30.3 x 24.7 cm (11 15/16 x 9 11/16 in)
McMichael Canadian Art Collection, Kleinburg
Purchase, 1987

Carmichael's work as a mature artist shows many affinities with Thomson's, among them the use of rich colour, strong pattern, and powerful design. The sketch for October Gold *was painted on Cameron Avenue in Willowdale, where he was born (the area was once known as Lansing). The view from a height gives a dramatic effect: it was taken from the north end of Hogg's Hollow in York Mills, the top of Yonge Street in Toronto. The birch bent over the ravine is an interesting compositional device. In developing the sketch into the canvas, Carmichael increased the size of the background and strengthened the birch tree. To the foreground he added a stump (at right) and a rock (at left) to push the image farther back and give it more importance.*

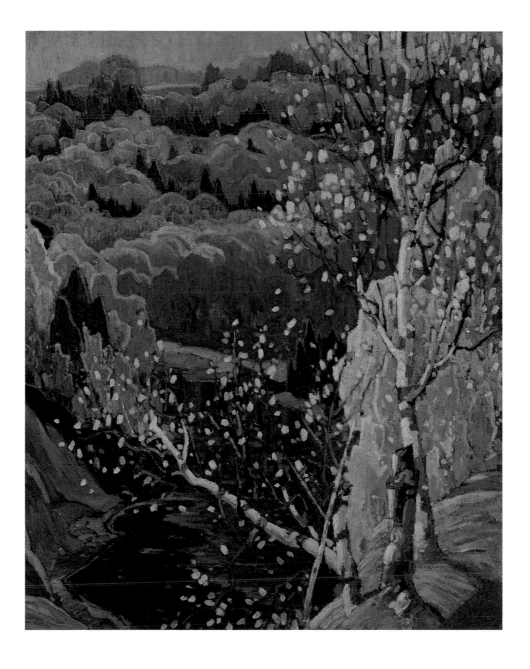

PLATE 74

J. E. H. M A C D O N A L D

Young Canada, 1922

Oil on canvas
52.3 x 65.8 cm (20⅝ x 25⅞ in)
The Robert McLaughlin Gallery, Oshawa
Gift of Isabel McLaughlin, 1987

Some of the paintings by the Group of Seven were more lyrical. A case in point is MacDonald's Young Canada, *in which the little tree in the foreground symbolizes the new nation. Isabel McLaughlin, who originally owned the work, believes that only a painter who was also a poet could produce such an essentially poetic painting.*

The painting has another happy conception besides the title: as we look, yellow leaves seem to fall in the forest and on the rocky forest floor. The warm reds and strong greens lend a cheerful note to the scene.

MacDonald submitted the painting to the Academy as his diploma picture at the time of his election. It was not accepted.

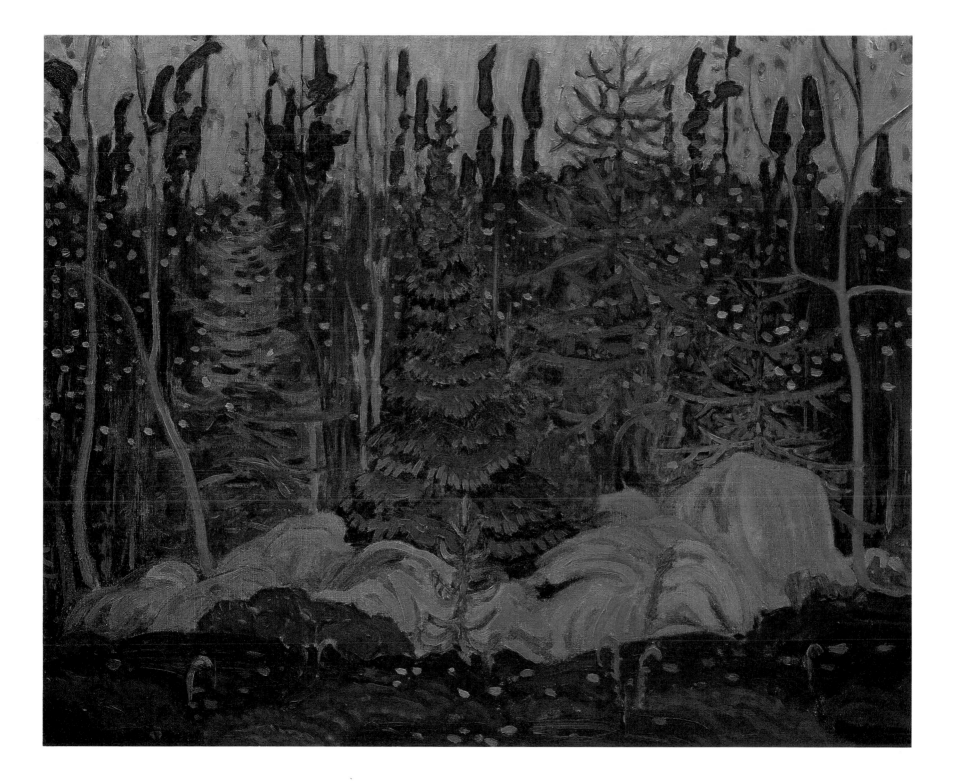

J. E. H. MACDONALD

A Nova Scotia Fishing Boy

Oil on board

21.5 x 26.0 cm (8¼ x 10¼ in)

Ken Thomson, Toronto

In July 1922, MacDonald went to Nova Scotia to paint in the vicinity of Petite Rivière. He fell in love with the long lines of the horizon, which were repeated in the shore and waves, but took time out from his paintings on the subject to essay this fresh, thoughtful figure sketch.

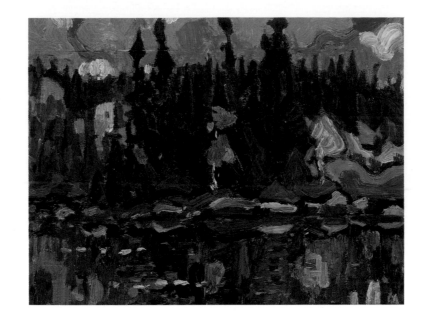

PLATE 76

ARTHUR LISMER

Sketch for *Isles of Spruce*, c. 1922

Oil on panel
22.9 x 30.5 cm (9 x 12 in)
Hart House Collection,
University of Toronto
Purchase, 1928

In 1921, a second boxcar trip to Algoma was made by Lismer, Harris, MacDonald, and MacCallum. At Sand Lake, Lismer found these islands of spruce, which he recorded in two thumbnail pencil notations to catch the general composition, and in an oil sketch (these are in Hart House). From these sources he took the central motif we see in the painting. He changed many other details, such as the strongly worked gold tree of the sketch, which he made the cheerful yellow-gold tree in the foreground of the island, and the time of day, which he fixed as twilight. To the surface of the water, he added ripples and rocks; to the rocks and trees, dark contour lines. The final canvas is not only more readable but powerful in a way that is unusual for Lismer. The contrejour *effect of the dark trees against the lighter sky (the French term, à* contre-jour, *means "against the light"), which is more characteristic of Harris, suggests his source of inspiration was this companion with whom he had made this trip.*

Fred Housser said in his 1926 book about the Group that, in the picture, Lismer raised a typical northern scene to the level of heroic allegory. He felt the viewer could sense in the work the invisible forest life; it made Isles of Spruce *"so still, so dark, so lonely and remote."*

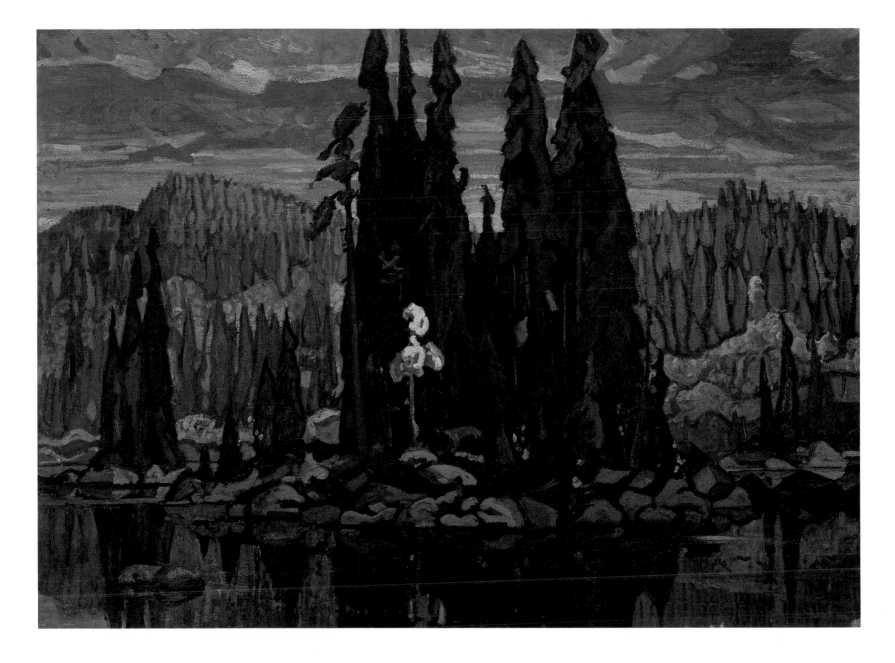

PLATE 77

ARTHUR LISMER

Isles of Spruce, c. 1922

Oil on canvas

119.4 x 162.5 cm (47 x 64 in)

Hart House Collection, University of Toronto

Purchase, 1928

LAWREN HARRIS

Sketch for *Above Lake Superior*, 1921

Oil on board
26.5 x 35 cm (10½ x 13½ in)
Ken Thomson, Toronto

Although several members of the Group provided leadership, Harris provided the crucial inspiration. The austere, intellectual quality of his thinking is revealed in his work, which is simpler and cooler in tone than that of the others.

This painting was pivotal in his development: it marks a turn away from his earlier work, the paintings of downtown Toronto, to a new phase which led, in increasing steps, to abstraction. Harris went to Lake Superior with Jackson in 1921, and quickly realized he had found what was for him the perfect painting country. It fulfilled his desires for a simplified, pared-down land, with an effect of grandeur and tremendous vista. The water seemed to stretch to infinity.

At the time, Harris was becoming increasingly involved with Theosophy. He saw a way to convey a subtle lesson about nature and the supernatural rolled into one in his work. He reached for one of the sketches he did of Lake Superior and reworked it slightly, making the clouds into a series of receding waves and adding treetops to the lower slopes of the facing hill, which probably looked too bare without them. He conveyed the spiritual essence of the scene through the sharp white light of the North which falls on the birches and snow. The light may have seemed to him a metaphor for Theosophy, which adherents believed was represented by the white light of pure truth. However, there is nothing slavish about the point he makes.

PLATE 79

L A W R E N H A R R I S

Above Lake Superior, c. 1922

Oil on canvas

121.9 x 152.4 cm (48 x 60 in)

Art Gallery of Ontario, Toronto

Gift from the Reuben and Kate Leonard Canadian Fund, 1929

PLATE 80

LAWREN HARRIS

First Snow, North Shore of Lake Superior, 1923

Oil on canvas
123 x 153.3 cm (48⅓ x 60⅜ in)
Vancouver Art Gallery
Founders' Fund, 1950

The rich, warm colouration of this stark landscape evokes the way colour was used in a sort of tapestry by Jackson, with whom, in the fall of 1922 and 1923, Harris made visits to the North Shore. Jackson later reminisced about their camping experiences on Lake Superior, recalling that they liked to camp near a sandy beach and go swimming, although the water was very cold. In the distance is the lake.

PLATE 8 1

LAWREN HARRIS

From the North Shore, Lake Superior, 1923

Oil on canvas

121.8 x 152.3 cm (48 x 60 in)

London Regional Art and Historical Museums

Gift of H.S. Southam, Ottawa, Ontario, 1940

Ann Davis recently selected this painting as the springboard for an exhibition, catalogue, and later a book, all titled The Logic of Ecstasy. *As she said, in this work Harris used the landscape of Lake Superior to depict both natural phenomena and other-worldly interests, as well as space and movement to underline a higher concern with the soul. "Both the real and ideal are apparent," she says, and she compares the work with El Greco's* The Burial of Count Orgaz *(though without the saint). Harris often focused on northern light in his Lake Superior canvases and sketches. He had read deeply in transcendental literature and believed in the immediate presence of eternity. Note the curtain of cloud which lifts to show a distant horizon: this popular compositional tool was often used by the Group of Seven.*

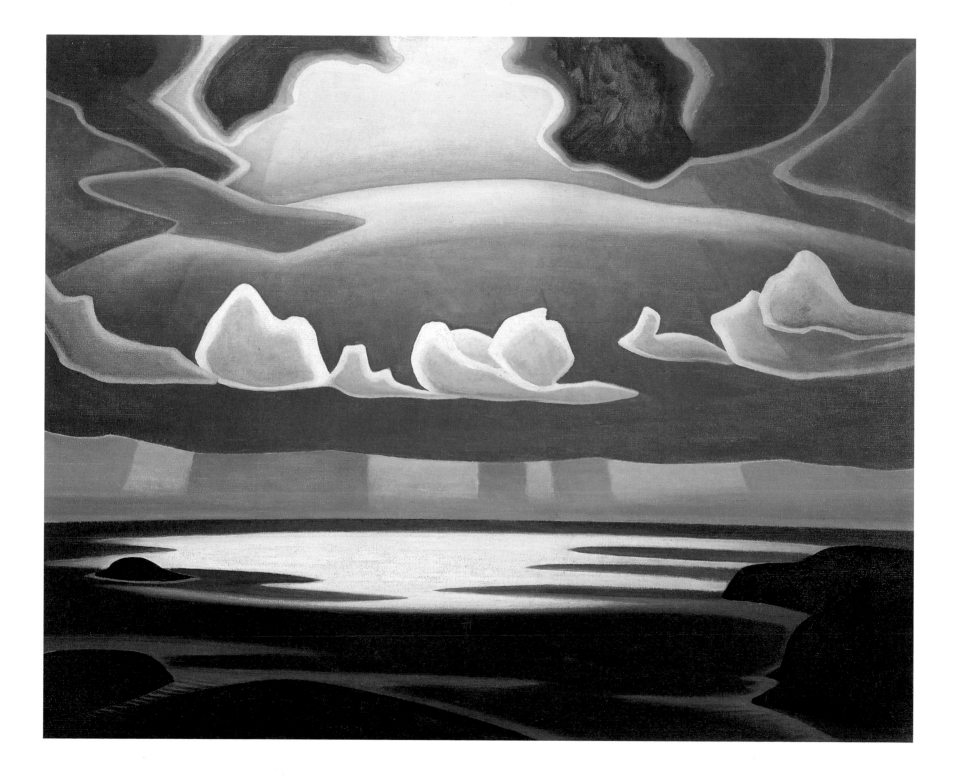

In 1921, the Winnipeg painter FitzGerald went to New York to study for a year at the Art Students' League. On his return, his work showed a stronger sense of form and bolder colour. His kind of painting, with its stripped-back images and deftly (though often thinly) handled paint, and his themes of western nature, impressed members of the Group. They invited him to become a member in 1932.

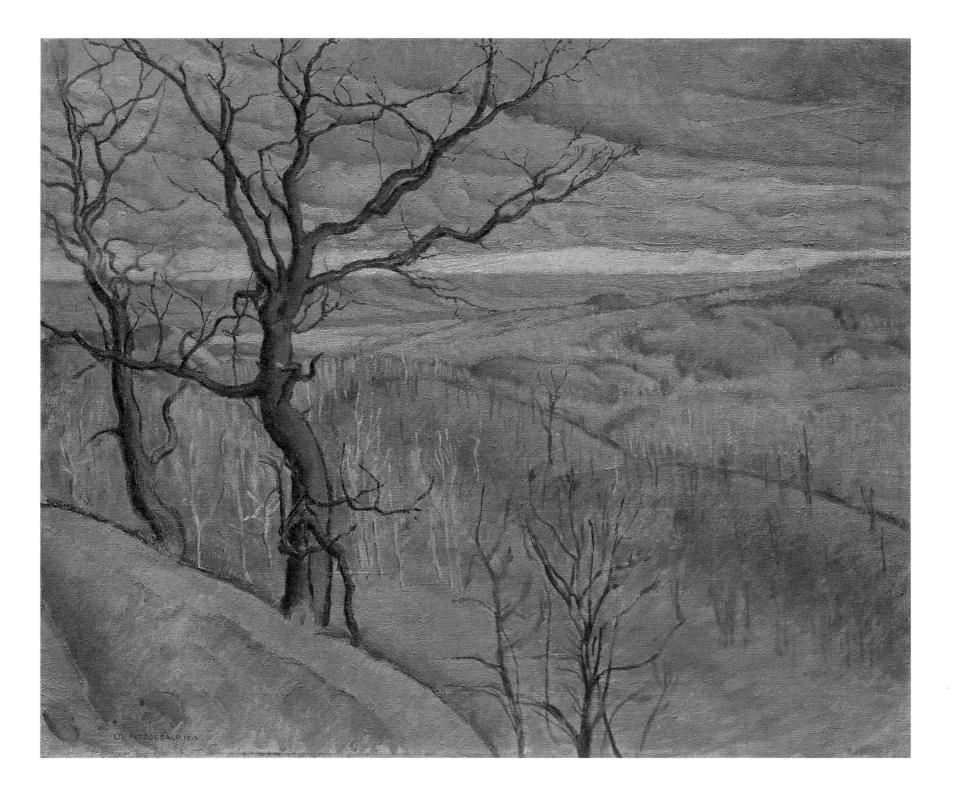

A. Y. JACKSON

Algoma Rocks, Autumn, c. 1923

Oil on canvas

81.7 x 100.8 cm (32⅛ x 39⅝ in)

Art Gallery of Ontario, Toronto

Bequest of Charles S. Band, 1970

Jackson's paintings, with their flat, tapestry-like surfaces, rich colours, and off-beat compositions, look surprisingly contemporary. This painting was owned by the collectors Charles and Helen Band of Toronto.

LAWREN HARRIS

Clouds, Lake Superior, c. 1923

86.5 x 102.0 cm (34 x 40¼ in)
University of Guelph Collection, Macdonald Stewart Art Centre, Guelph
Gift of Dr. Frieda Helen Fraser, Burlington,
in memory of Dr. Edith Bickerton Williams, 1988

Harris made many monumental canvases of stark wilderness landscapes from sketches along the north shore of Lake Superior between 1911 and 1924; they are among his most powerful compositions. In this view of a sunrise from a hilltop, the eye is led to the clouds by the light which falls on the water surrounding the undulating island forms. (These recall a beaver submerged as it swims in the water.) In 1923, Harris exhibited a related work in a show; it aroused the ire of the Russian artist Leon Bakst, who remarked that it was "sculpture rather than painting." The work is a new arrival on the public gallery scene; it had been in a private collection since Harris had given it as a wedding gift to the donor.

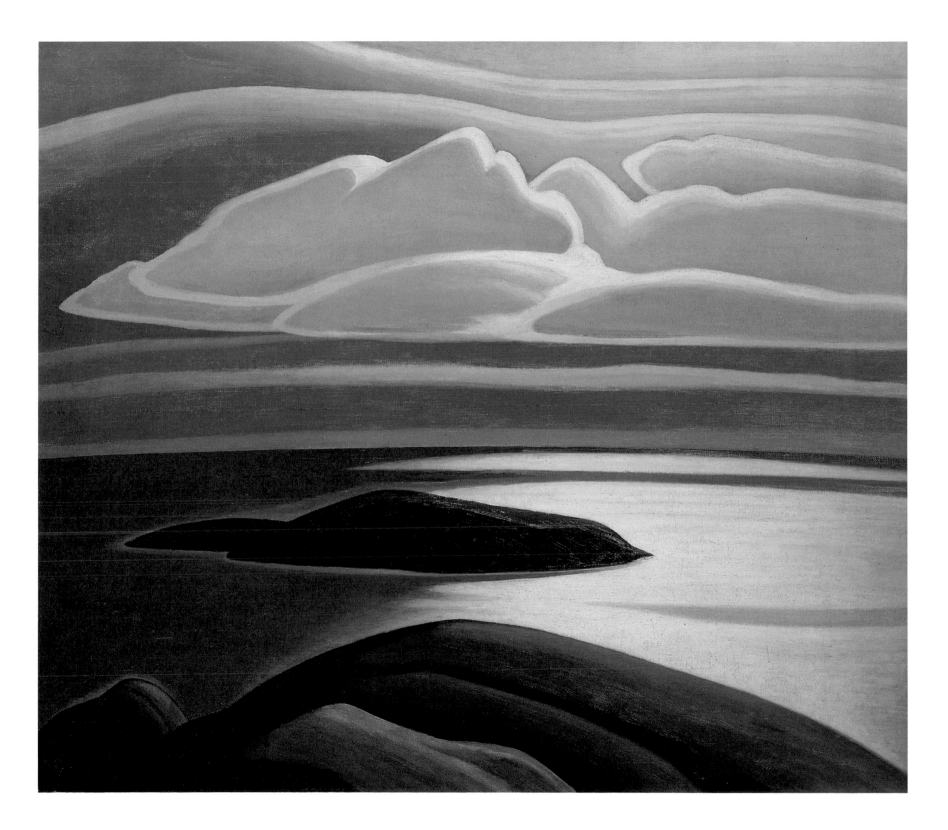

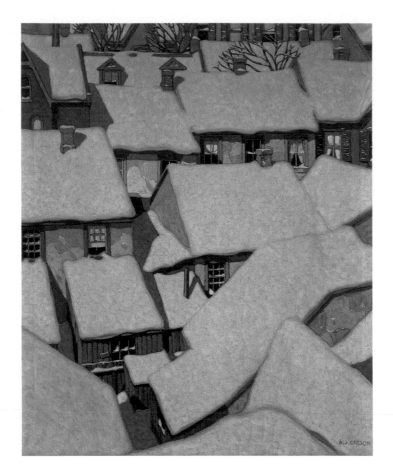

PLATE 85

A. J. CASSON

House Tops in the Ward, 1924

Oil on canvas
113.0 x 93.0 cm (44½ x 36⅝ in)
Ken Thomson, Toronto

The Ward area of Toronto had been a favourite subject of Harris's. When Casson painted it, he focused on the pattern of the snow-covered rooftops. The blue shadows are vital to the design and give the painting a sense of three-dimensional volume. Casson did not forget the exciting lesson about powerful design and composition which he had learned from House Tops in the Ward *when he painted* Mill Houses. *In this picture too, the rooftops convey the curving pattern of the composition, which is echoed in the S-shaped stream.*

In 1926, Casson was invited to become a member of the Group of Seven. That same year he bought his first car, and began to explore villages in Ontario (the mill houses were in Rockwood). The Ontario small town was to become his specialty, just as the villages of French Canada were Jackson's.

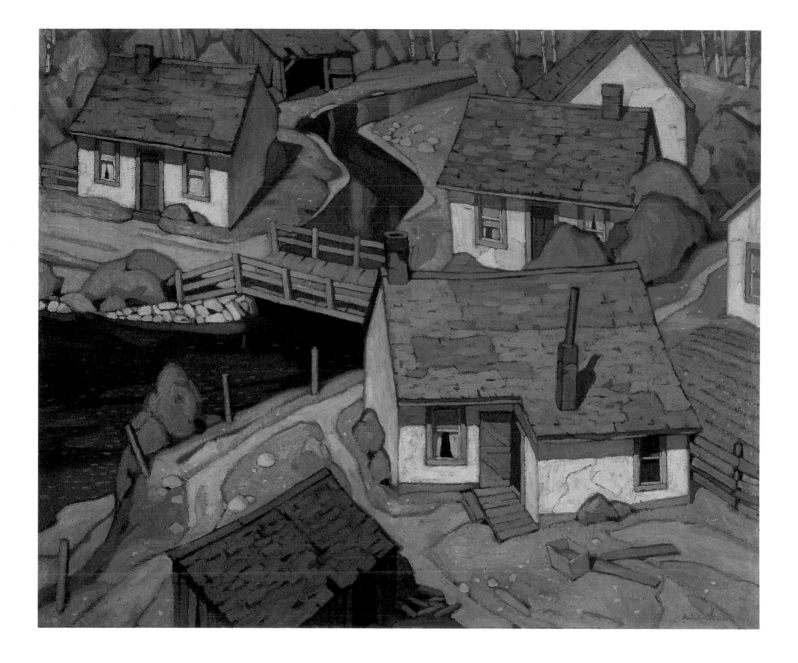

PLATE 86

A. J. CASSON

Mill Houses, 1928

Oil on canvas

76.2 x 91.4 cm (30 x 36 in)

Agnes Etherington Art Centre, Queen's University, Kingston

Gift of Mr. and Mrs. Duncan MacTavish, 1955

EDWIN HOLGATE

The Lumberjack, 1924

Oil on canvas

64.8 x 56.6 cm (25½ x 22¼ in)

Gallery Lambton/Cultural Services, Sarnia

Gift of Sarnia Women's Conservation Art Association, 1956

Holgate was the one member of the Group who lived in Montreal. He also had a summer shack, at Lake Tremblant in the Laurentians, which he had built himself. In 1924 he asked a local lumberjack to pose for a portrait. His subject, the best axe-handler in the Lake Tremblant area, was tall, and part Indian; he came from the Gatineau River valley, near Ottawa.

In Holgate's portrait, the lumberjack exudes toughness and resilience. He seems to look past the viewer quietly — he will endure. The way his big hands grasp the axe shows his strength. Holgate reinforced the rugged quality of his subject by simplifying the planes of the face and hands, and broadly outlining the shirt. The logs behind him indicate not only his profession but the job to be done.

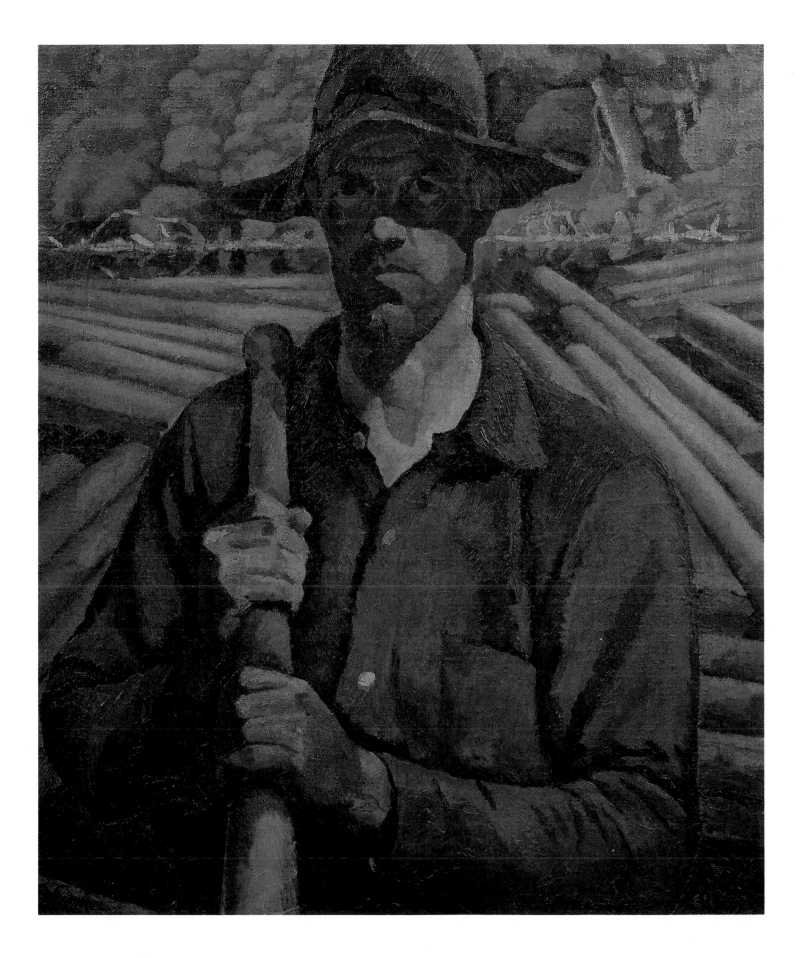

Varley painted and drew Vincent Massey's portrait twice in the period from 1920 to 1922. His portrait, which is in the collection of Hart House, University of Toronto, reveals an austere, gloomy nature. Varley's portrait of Alice Massey, in the National Gallery of Canada (a gift of her husband in 1968), is correspondingly regal: she is Queen to Vincent Massey's King. Yet where Massey is dark, she is radiant; where he looks wan and troubled, she is calm and self-possessed. This portrait, which has only recently come to light, gives us a straightforward look at her angular, high-coloured face. She was a strikingly handsome woman, with fine, classical features, says Claude Bissell, the biographer of her husband. Known as "Lal," she was eight or nine years Vincent's senior, but she had great vivacity and vigour. She seems to have posed only for an instant here.

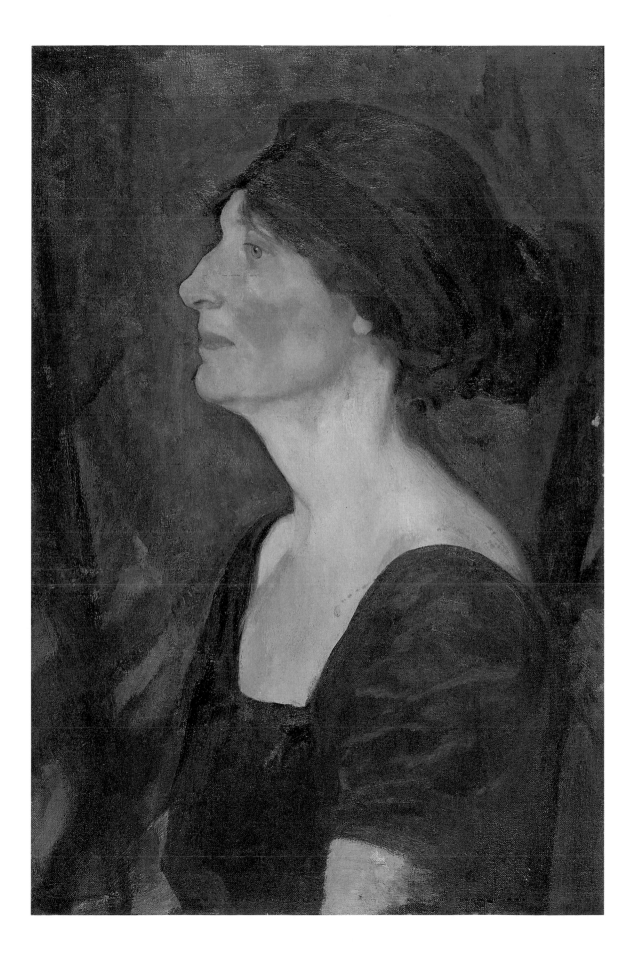

PLATE 89

LAWREN HARRIS

Dr. Salem Bland, 1925

Oil on canvas
103.5 x 91.4 cm (40¾ x 36 in)
Art Gallery of Ontario, Toronto
Gift of *The Toronto Daily Star*, 1929

Salem Goldworth Bland (1859 - 1950) was ordained a minister of the Methodist Church in 1884, and became a minister of the United Church in 1925. He wrote for The Toronto Daily Star *and was the author of several books.*

Ann Davis, in her book on Canadian mystical painting, The Logic of Ecstasy, *comments on the way Harris focused in this portrait on Bland as a mystical seer. The bold symmetry and full frontality of the pose accentuate the straight-ahead gaze of Bland's unblinking grey-blue eyes. He looks not at us, but through us, says Davis. The light on his face makes him appear to shine with illumination. Davis mentions Harris's control and precision in painting the work: the sombreness of Bland's clothes is relieved only by touches of white, and by his rapt face and firmly clasped hands. Harris would have been sympathetic to Bland's contemplative mood.*

PLATE 90

LAWREN HARRIS

North Shore, Lake Superior, 1926

Oil on canvas
102.2 x 128.3 cm (40¼ x 50½ in)
National Gallery of Canada, Ottawa
Purchase, 1930

Some critics consider North Shore, Lake Superior *the most remarkable work of Harris's career. It is to them an icon combining the natural and the spiritual.*

The stump is set high on a rocky shore above Lake Superior. On the horizon are bands of yellow light, which represent for some viewers "the occult life-essence." Others, such as Jackson, always the pragmatist, spoke of the picture as "The Grand Trunk" because it is of a tree trunk. Harris discovered the motif for the work on a trip to the Coldwell area with Jackson in 1925. Jackson later recalled that the stump was almost lost in the bush, but Harris isolated and created a nobler background for it. There probably was a long process of refinement. Harris spoke of the great North, with its implicit "loneliness and replenishments, its resignations and release, its call and answer — its cleansing rhythms." The sculptural forms of the clouds encircle the flow of illumination from an unseen source. The viewer may feel it is the light of the spirit.

In 1931 the painting won the Art prize at the Pan-American exhibition of contemporary painting at the Baltimore Museum of Art. It was quickly recognized as a classic statement of the Canadian North. In his later paintings of Lake Superior, Harris's forms became increasingly abstract. He continually strove to express, ever more intensely, a spiritual and mystical quality.

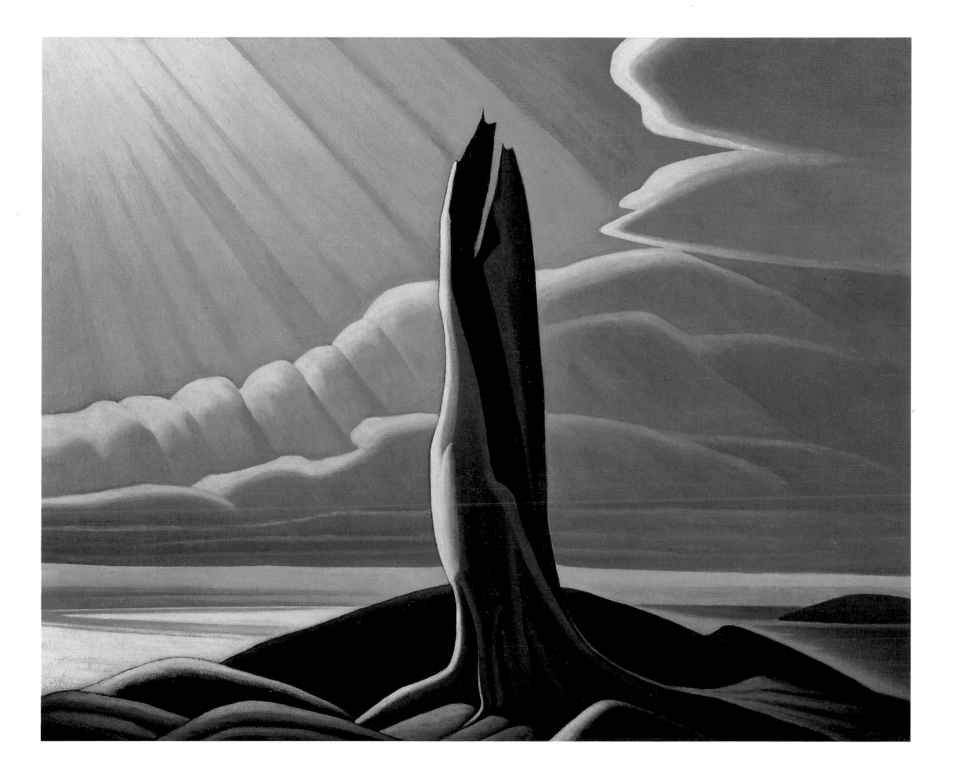

PLATE 9 I

LAWREN HARRIS

Mountains, Moraine Lake, c. 1926 (?)

Oil on panel
30.4 x 37.9 cm (12 x 14⅞ in)
The Robert McLaughlin Gallery, Oshawa
Gift of Isabel McLaughlin, 1993

In 1926, Harris exhibited an abstract mountain composition, Mountain Forms, of so simple a format that it startled critics. One writer in the Toronto Mail and Empire noted that his mountains rose like "great teeth of cosmic lime out of calm lake pedestals." Harris's friend Fred Housser, however, wrote perceptively in The Canadian Bookman about the work, noting that its "daring composition was a union of the principles of painting, music and sculpture."

It is tempting to date this sketch to 1926, the year of Housser's review; since he owned it, he would have known of its importance. It is the sketch for a major painting, In the Mountains. After Housser died, his wife, painter Yvonne McKague Housser, gave the sketch to her friend Isabel McLaughlin, and she in turn gave the sketch to the Robert McLaughlin Gallery, of which she is the benefactor. The sketch is one of the most hauntingly spiritual of Harris's career. In it, the mountain is bathed in a beam of intense light. The cloud formation varies the composition; the smooth, rounded snow-forms at the top of the rock balance the angular rock formation.

Mountains held a special significance for Harris. Besides their value as a mystic emblem, they seemed a symbol of artistic striving, and thus a worthy subject for a generation of budding abstract painters, of which Harris was one. Harris wrote that, if we viewed a great mountain soaring into the sky, it might evoke within the viewer an uplifting feeling. "There is an interplay of something we see outside of us with our inner response," said Harris. "The artist takes that response and . . . shapes it on canvas with paint so that when it is finished it contains that experience."

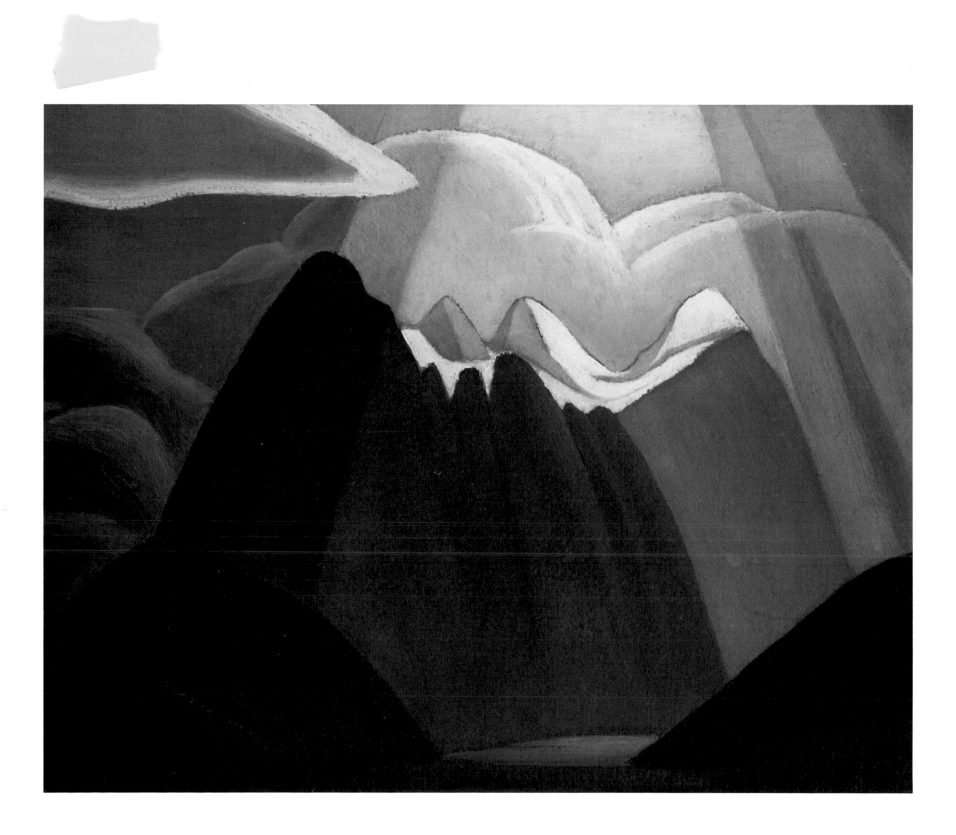

PLATE 92

FRANK H. (FRANZ) JOHNSTON

Blue and Gold, Algoma, c. 1926

Oil on pressed board
55.5 x 46.5 cm (21⅞ x 18¼ in)
The Robert McLaughlin Gallery, Oshawa
Gift of M. Scharf, 1982

Franz Johnston was a member of the Group for only a single year, 1920. He then went west to work as principal of the School of Art in Winnipeg. His common painting practice differed slightly from that of the Group. He favoured oil wash or gouache paint, both of which give the surface more of a matte effect. The medium, because it is a wash, allowed fine brush strokes and a more calligraphic line. Johnston also often selected a crowded, close-up view, unlike the vistas favoured by some of the other members of the Group.

Algoma was a favourite Group painting area.

PLATE 93

EDWIN HOLGATE

Totem Poles, Gitsegiuklas, 1927

Oil on canvas
80.9 x 81.1 cm (31¾ x 31⅞ in)
National Gallery of Canada, Ottawa
Purchase, 1939

In the summer of 1926, Holgate accompanied Jackson and the anthropologist Marius Barbeau to the Skeena River in northwest British Columbia. Holgate stayed a month and a half to study the villages of the Gitskan, one of the subnations of the Tsimsian. Art historian Dennis Reid said that Holgate found the experience profoundly melancholic. Holgate wrote that he felt he was "witnessing the rapid decline of a splendid race of creative and well-organized people. There persisted a brooding gloom which I found it impossible to dispel."

From the sketches he did on the Upper Skeena, he developed this painting in his studio in Montreal. Unlike Jackson, who focused on the landscape (see Pl. 94), Holgate focused on the totem poles: they frame the Indian houses. At the centre of the scene, a mute story unfolds: an Indian girl looks at a sleeping dog. As in much of Holgate's work, the handling is solid and three-dimensional. This sense of solidity and compactness is characteristic of Holgate.

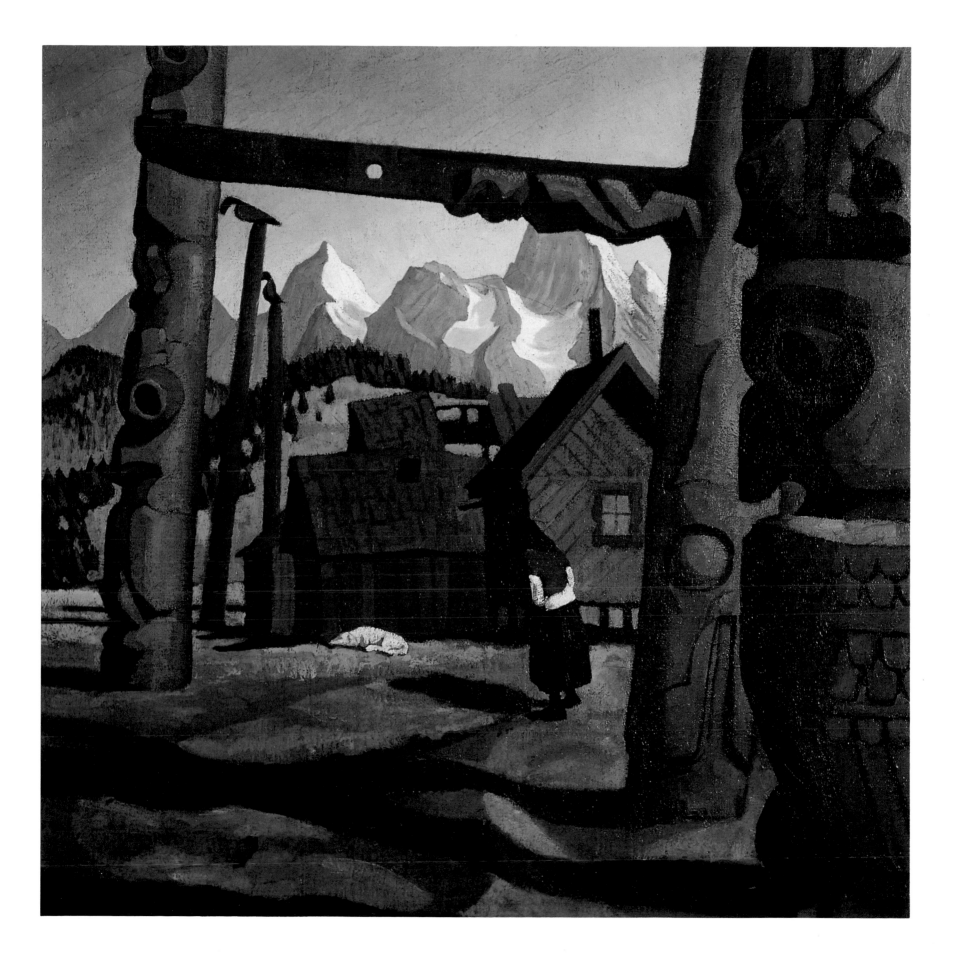

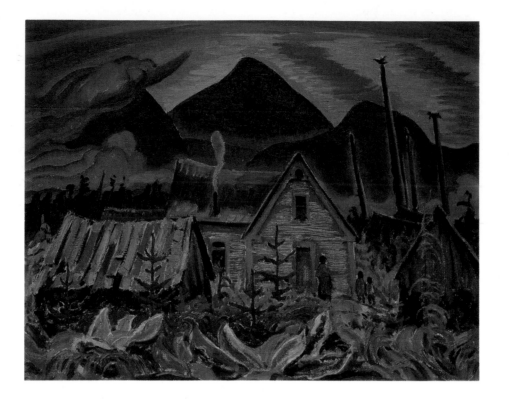

PLATE 94

A. Y. JACKSON

Indian Home, 1927

Oil on canvas

53.8 x 66.5 cm (21⅛ x 26⅛ in)

The Robert McLaughlin Gallery, Oshawa

Gift of Isabel McLaughlin, 1987

Indian Home was one of Jackson's favourite paintings. He considered it one of his best Skeena River subjects, and liked to include it in shows, as his niece, Naomi Jackson Groves, recalled. The reason lies in the authentic quality of the scene conveyed by the painting. The Indian home and leaning totem poles are particularly well drawn, as is the mountain in the distance. Jackson captured the moment when a storm was rolling up. Groves believes it was Jackson's canvases on Skeena subjects that gave Emily Carr, while on a visit east in 1927, a new idea of the richness and poetic mood attainable in the British Columbia landscape that she took back with her and used to paint her own great visions. Other scholars such as Peter Mellen find that, in painting the houses and totem poles, Jackson lost a sense of the scene as a whole. "Except for the mountains in the distance, this could almost be a scene in rural Quebec," Mellen comments, and he records that Carr liked the rhythm and poetry in Jackson's work, yet sensed that he did not really have a feel for the west as he did for the east.

PLATE 95

A.Y. JACKSON

Detail of *Indian Home*, 1927

 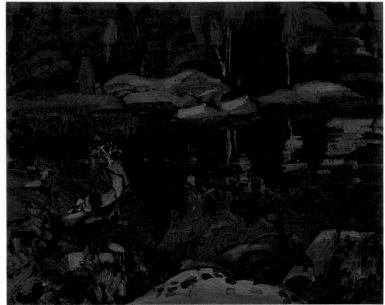

PLATE 96

ARTHUR LISMER

Sketch for *Little Cove, Georgian Bay*, c. 1929

Oil on canvas board
33.1 x 40.7 cm (13 x 16 in)
The Robert McLaughlin Gallery, Oshawa
Gift of Isabel McLaughlin, 1987

PLATE 97

ARTHUR LISMER

Sketch for *Little Cove, McGregor Bay*, c. 1929

Oil on board
21.5 x 26.0 cm (12½ x 15½ in)
Ken Thomson, Toronto

One of Lismer's happiest painting spots was McGregor Bay in Georgian Bay, and many of his works, among them this canvas (right), were inspired by the place. His habit, as with other members of the Group, was to work in the studio from a sketch done on site. Changes are evident when the sketches used for the work and the finished canvas are compared. He increased the amount of detail in many of the areas, especially in the foreground, where we find much more finished pine trees and boulders. Moreover, the shape of the foreground pine tree is more interesting, and the greenery on its branches more filled out. He also added green lily-pads on the water and, most important, a telling ripple, as well as stronger background trees. He clearly drew upon both sketches, however, taking the reflections on the water from one, and the shoreline rocks from the other. In some ways the central motif recalls the tree in Thomson's The West Wind *(Pl. 39), but here all is tranquillity and peace. There is no wind, only a still day.*

Isabel McLaughlin bought the painting from Lismer around 1937 or 1938. He used the money from the sale to send Gordon Webber, one of his talented students, to the School of Design in Chicago to study with László Moholy-Nagy. She probably purchased the sketch at the same time.

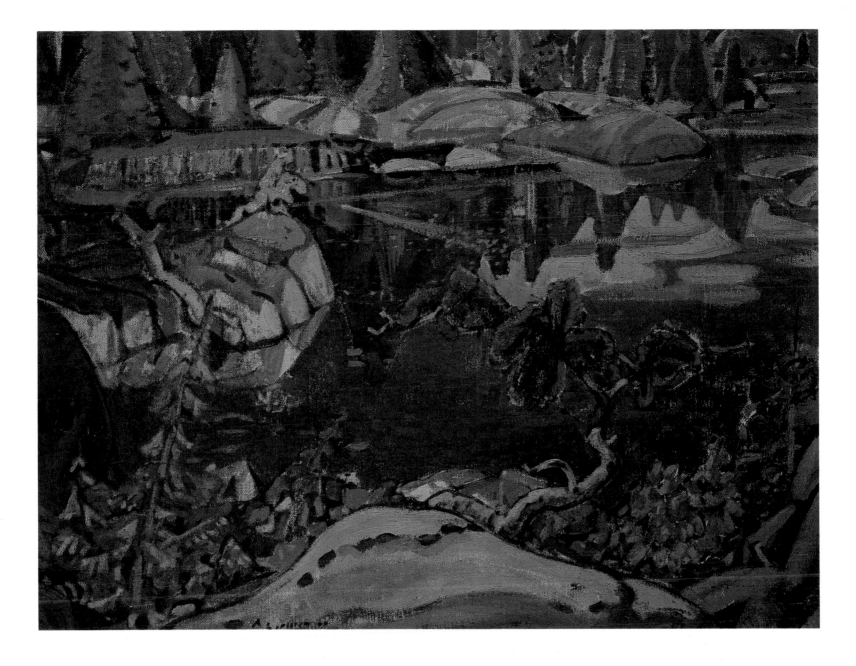

PLATE 98

ARTHUR LISMER

Little Cove, Georgian Bay, 1929

Oil on canvas
80.5 x 100.6 cm (31¾ x 39⅝ in)
The Robert McLaughlin Gallery, Oshawa
Gift of Isabel McLaughlin, 1987

PLATE 99

ARTHUR LISMER

Sketch for *Old Pine, McGregor Bay*, c. 1929

Oil on board
32.7 x 41.0 cm (12⅞ x 16⅛ in)
Art Gallery of Ontario, Toronto
Bequest of Ambia L. Going, Peterborough, Ontario, 1938

This is one of Lismer's most successful Georgian Bay subjects. Housser said that Lismer's best canvases, while their place and time are specifically Canadian, burst through to the timelessness which is characteristic of all great art. In paintings such as this, Housser said, one feels that Lismer has studied the anatomies of all trees, felt their joints, and experienced the throes of their creation. "It is an allegorical tree. In it he has gathered up the epic spirit of innumerable great trees which have been wounded by storms and healed themselves again," said Housser. Lismer increased the sense of windy weather in the canvas by painting a sky filled with clouds.

PLATE 100

ARTHUR LISMER

Old Pine, McGregor Bay, 1929

Oil on canvas

82.5 x 102.2 cm (32½ x 42¼ in)

Art Gallery of Ontario, Toronto

Bequest of Charles S. Band, 1970

PLATE 101

FRANKLIN CARMICHAEL

Wabajisik: Drowned Land, 1929-30

Watercolour and gouache over charcoal on woven paper
51.8 x 69.8 cm (20⅜ x 27½ in)
National Gallery of Canada, Ottawa
Purchase, 1993

Though Carmichael produced many impressive oil paintings, his greatest achievement was in the watercolour medium; with it, he was able to convey an airy openness and lightness, combined with sound structure. This watercolour is a good example of Carmichael at his best. Notice the way he used the white paper and let it show through to create the effect of the piled-up clouds and whitened birch trunks in the water. The image recalls an early sketch painted by Thomson, which he could have shown to Carmichael. The two painters had shared a studio in 1914, and the influence on Carmichael was profound. He absorbed Thomson's way of understanding the structure of the land.

Carmichael's esteem for, and belief in, the independence and validity of the watercolour medium led him in 1925 to found — with F.H. Brigden — the Canadian Society of Painters in Water Colour. He wanted to find his own style of interpretation, he once said, within the Group. Watercolour is a delicate medium and enabled Carmichael to convey his sense of light and be himself — quiet, precise, brilliant. He used the dry method, in the English watercolour tradition, thinking perhaps of such watercolourists as Samuel Fowler and John Sell Cotman as models. But he found a way to express the shape of clouds which was uniquely his. Even later, as a teacher, he used to urge students like Charles Goldhamer to capture the shape of the clouds. That was the key, he felt, to success.

Carmichael's watercolours are hard to copy because they're simple and tonal. Casson recalled that Carmichael was the one who told him to use a thin coat of yellow ochre to control the sizing in the Whatman paper they favoured. For Carmichael, watercolour was the supreme medium, one attuned to his subtlest impulse. He was a subtle man.

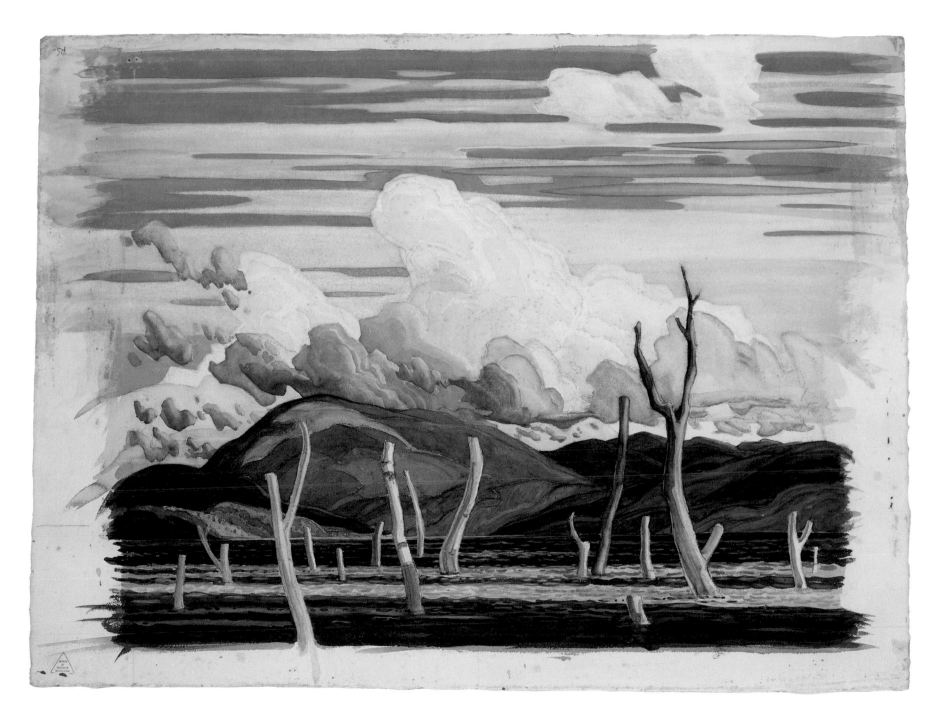

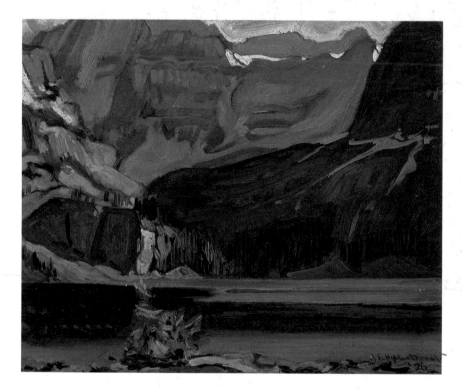

PLATE 102

J. E. H. MACDONALD

Lake O'Hara, Rockies

Oil on board
21.5 x 26 cm (8¼ x 10¼ in)
Ken Thomson, Toronto

PLATE 103

J. E. H. MACDONALD

Larch Trees, c. 1929

Oil on cardboard
27.5 x 23.5 cm (10¹³⁄₁₆ x 9¼ in)
Hart House Collection, University of Toronto
Gift of Graduating Year, 1925

Beginning in 1924, MacDonald made seven trips to the Rockies, and painted some of his best work there. Artists such as John Singer Sargent had noticed a special problem in painting the mountains — they are so big that it's hard to keep in both the tops and the bottoms. MacDonald solved the problem by focusing on one area at a time, to the exclusion of the other. He also found appealing contrasts of light: a light sky or snow against dark hills, or blue sky and tan peaks which form a contrast to pale green rock slabs.

PLATE 104

J.E.H. MACDONALD

September Snow on Mount Schaffer, C. 1929

Oil on cardboard
21.4 x 26.5 cm (8⁷⁄₁₆ x 10⁷⁄₁₆ in)
National Gallery of Canada, Ottawa
Purchase, 1947

PLATE 105

F. H. VARLEY

Dawn, c. 1929

Oil on panel

30.5 x 38.0 cm (12 x 15 in)

Vancouver Art Gallery, Vancouver

Purchase, 1986

Varley's Dawn *evokes Whistler's nocturnes, but for his landscape he looked to the North Shore hills across from Jericho Beach in Vancouver. There is more than a slight echo of Oriental art in the simple, spacious forms.*

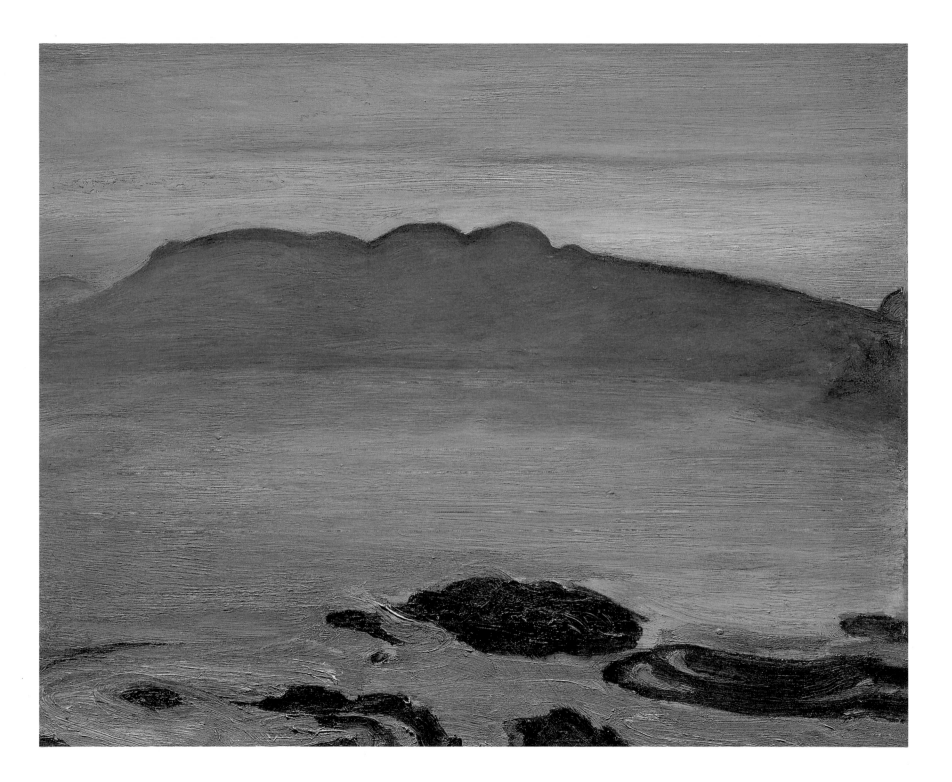

PLATE 106

LAWREN HARRIS

Lighthouse, Father Point, 1930

Oil on canvas
107.9 x 128.1 cm (42⅜ x 50⅜ in)
National Gallery of Canada, Ottawa
Gift of the artist, Vancouver, 1960

In the fall of 1929, Harris travelled with Jackson to Métis Beach, east of Rimouski, on the south shore of the St. Lawrence River. It was Harris's first trip to that region of Quebec. At the harbour village of Father Point, west of the beach, he discovered a modern concrete lighthouse, of which he made several detailed pencil drawings. The day he was there was dark and cloudy. From these sketches, he painted a small, simplified oil study, then developed his large canvas. Although the beam was not activated when he was there, he painted a soft welling light in the sky which seems to radiate from the lighthouse.

For Harris, the structure was a majestic embodiment of transcendental thought. The painting glows with a supernatural calm. As art historian Jeremy Adamson has noted: "It was an emblem for the source of mystical illumination which shed light or truth onto the darkness of humankind's uninformed inner vision."

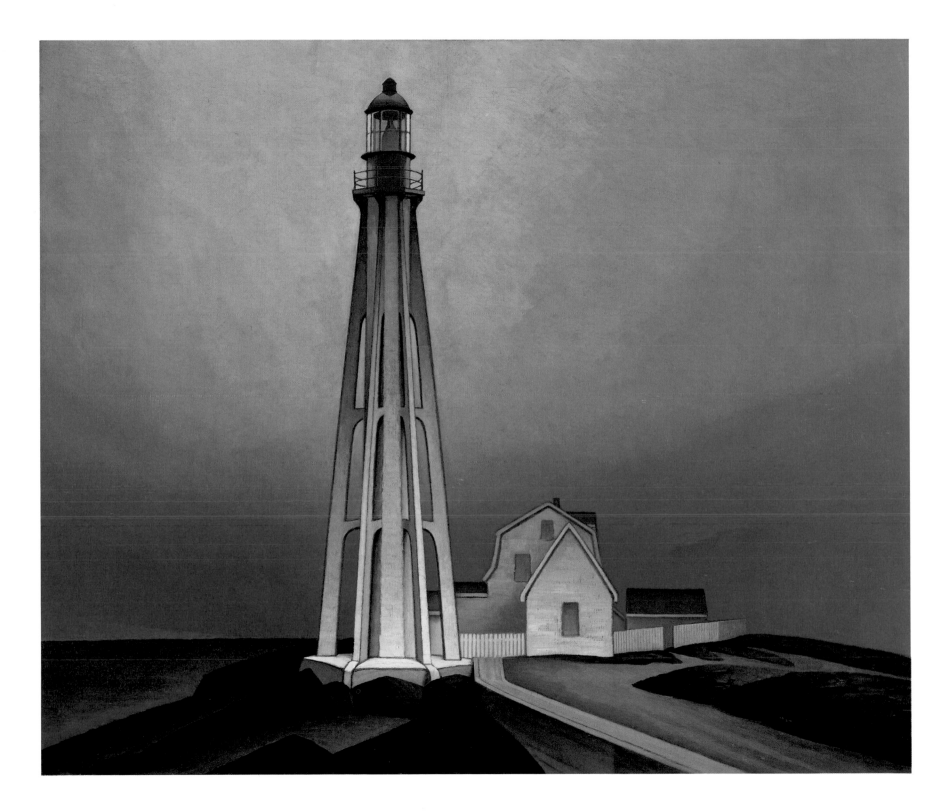

PLATE 107 ▲

FRANKLIN CARMICHAEL

A Northern Silver Mine, 1930

Watercolour on paper

22.0 x 26.9 cm (8⅝ x 10⁹⁄₁₆ in)

McMichael Canadian Art Collection, Kleinburg

Gift of Mr. and Mrs. R. Mastin, 1971

PLATE 108 ▶

Cobalt, 1930

Graphite on paper

27.7 x 21.5 cm (10⅞ x 8½ in)

McMichael Canadian Art Collection, Kleinburg

Gift of Mrs. R. Mastin, 1993

The Group of Seven was a movement which provided encouragement to those "who deserved to see our people liberated from the hypnotic trance of a purely industrial and commercial ideal," F.H. Housser wrote in 1926. They painted mostly Canadian landscape, but, by the end of the decade, Carmichael often drew upon the theme of the industrial north to probe the energies of the new Canada. Curator Megan Bice points out that the picture of an abandoned silver-mine shaft in Cobalt captures the uneasy relationship between the town and its surroundings. The mine in the painting is much darker and more ominous; the hills also look more agitated.

The watercolour sketch was squared off for transfer to the canvas; that is, Carmichael drew lines across the surface in a grid pattern so that he could transfer section by section to the larger, also squared-off canvas.

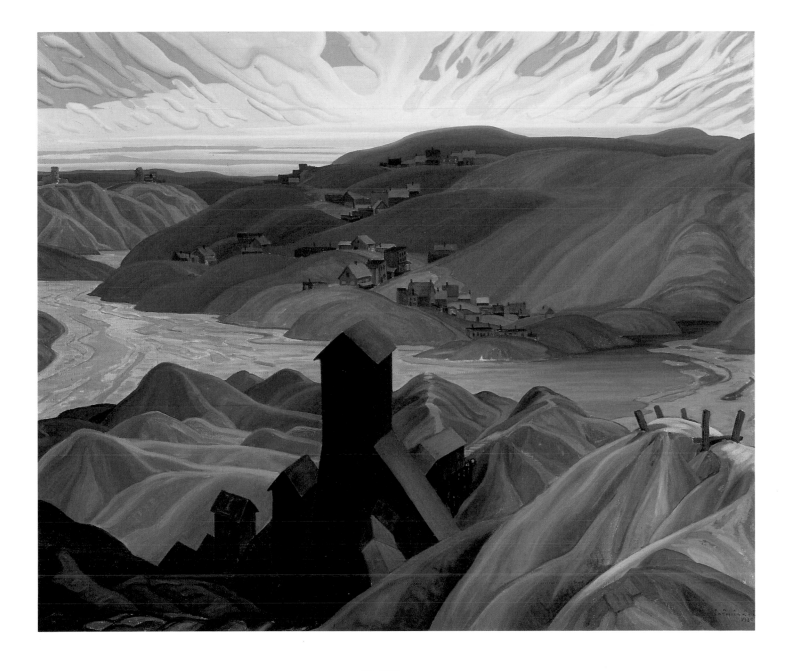

PLATE 109

FRANKLIN CARMICHAEL

Northern Silver Mine, 1930

Oil on canvas
101.5 x 121.2 cm (40 x 47¾ in)
McMichael Canadian Art Collection, Kleinburg
Gift of Mrs. A.J. Latner, 1971

PLATE 110

EDWIN HOLGATE

Nude, 1930

Oil on canvas
64.8 x 73.2 cm (25½ x 28⅞ in)
Art Gallery of Ontario, Toronto
Gift from Friends of Canadian Art Fund, 1930

Along with Varley, Holgate was one of the few Group members to paint the female nude. In 1930 he began a particularly interesting series of monumental figures, but he was careful to place them in landscapes. His cool three-dimensional treatment makes them look almost like sculpture. The various lines of the body are echoed in the forms of the rocks. He intentionally played upon the metaphor of "Mother Nature" and the female form.

Holgate's work is forward-looking. Painting the figure would be the theme of the next generation of painters, such as Pegi Nicol MacLeod, whom he taught.

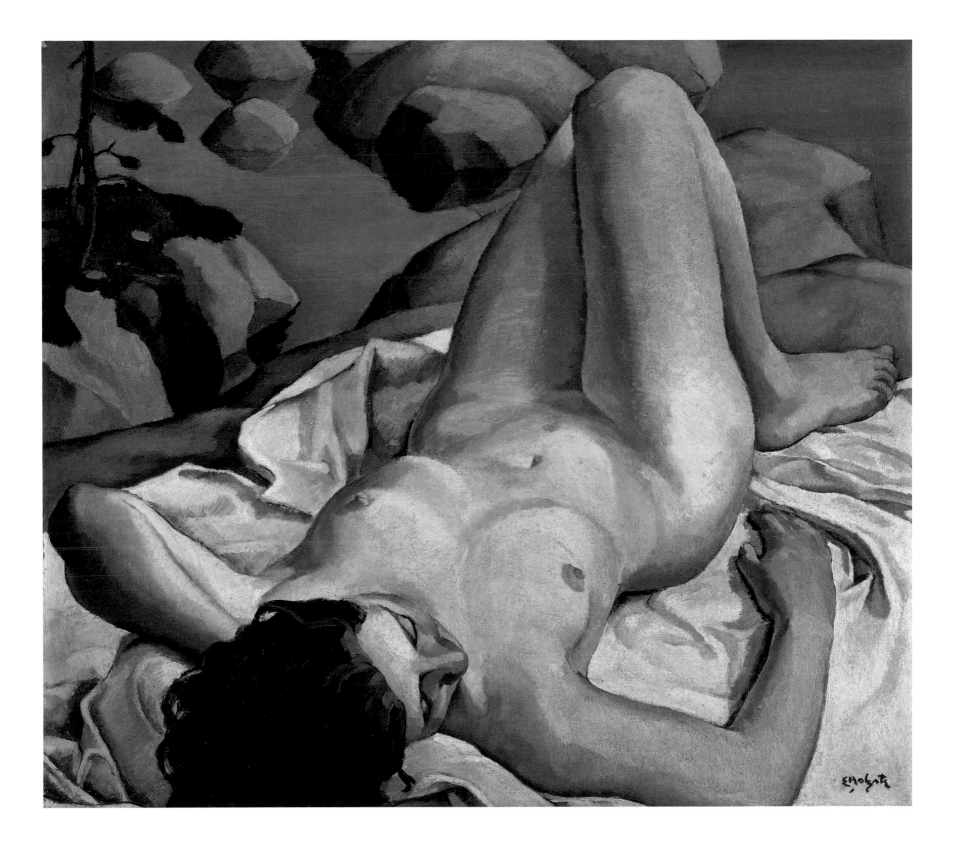

PLATE III

F. H. VARLEY

Vera, 1931

Oil on canvas
61.0 x 50.6 cm (24 x 19⅞ in)
National Gallery of Canada, Ottawa
Vincent Massey bequest, 1968

In this portrait of subtle and charming Vera Weatherbie, a student at the Vancouver School of Decorative and Applied Arts, where Varley taught, the subject looks at the viewer, yet seems to sit passively as though waiting to hear what we have to say. Her quiet interest adds to her charm.

The colours Varley used to paint Vera create a shifting curtain behind her head. She seems to be seated inside a green tent (actually, she is in shadow), though there is a light source at the left which gilds her forehead and cheek, and at the right. Varley intended his tones of green to evoke her spiritual nature; the violet, her artistic side.

PLATE 112

L.L. FITZGERALD

Doc Snyder's House, 1931

Oil on canvas

74.9 x 85.1 cm (29½ x 33½ in)

National Gallery of Canada, Ottawa

Gift of P.D. Ross, Ottawa, 1932

FitzGerald's work was much respected by the Group for its sensitivity and restraint. His stripped-back forms recall Harris, but the setting is quite different. He painted Winnipeg, where he lived. Dr. Snyder, a dentist, was a neighbour of his on Lyle Street, St. James, Winnipeg.

Harris wrote that, during the years of the Group of Seven, Jackson, a Montrealer by birth, spent a month or more at the end of each winter in his beloved Quebec villages — La Malbaie, Baie St. Paul, Les Eboulements, St. Hilarion, and St. Tite des Capes — or on the north shore of the Gulf of St. Lawrence; he loved the rolling farmland. Jackson would have painted this picture on one of these visits: the season is clearly the end of winter, as we can see from places where the snow has melted. Jackson may have been wearing the snowshoes which gave him the nickname Père Raquette, for he seems to have painted standing on a snowy hillside. He must have loved the way the farm was anchored, almost like a ship, by the hillocks of snow. The eye is led, step by step, to the distance; from the foreground, diagonally from the road to the house and then along the distant line of the road. The setting sun has given a pink and blue coloration to the snow. Note the touch of human life — a man walks toward the house.

About Les Eboulements, Jackson wrote: "A couple of hundred years ago one of the hills slid out into the river, making a cape or point about six hundred yards or so beyond the shore-line. It is all undulating little frills or 'eboules'. . . ."

PLATE 114

F. H. VARLEY

Open Window, c. 1932-33

Oil on canvas
102.9 x 87.0 cm (40¼ x 34¼ in)
Hart House Collection, University of Toronto
Purchased with income from the Harold and Murray Wrong Memorial Fund, 1944

In 1933, Lawren Harris helped found the Canadian Group of Painters, which replaced the Group of Seven. Naturally all of the Group who remained were members (MacDonald had died in 1932). Varley showed this work at the 1933 Canadian Group of Painters show at the (then) Art Gallery of Toronto. In it, he meant to show what he brought to the new Group. Yet its subject — the grandeur of nature — is characteristic of the Group of Seven. Varley painted the sketch from an upstairs window of his house in Jericho Beach, Vancouver. The room was his studio. The time of day is dawn. "British Columbia is heaven," he wrote a friend. "The sea is here, and the sky is vast. . . ."

That he painted the view from within the house, as we can see from the open shutters, is forward-looking. It suggests his interest in the work of Matisse; the painting was in the vanguard of the growing fascination with the urban scene among young painters in Canada.

PLATE 115

A. J. CASSON

Thunderstorm, 1933

Oil on canvas
76.2 x 91.5 cm (30 x 36 in)
Private collection, Toronto

Although these works are both of thunderstorms, Casson has chosen to depict this favourite Group of Seven subject in the context of an Ontario country village. Something of Harris's renderings of Lake Superior stuck in his mind in Thunderstorm: *his poles and solid clouds recall Harris, but the setting — the picket fence, the shades drawn down on the windows and the fact that the poles are for telephone lines — domesticates the older artist's wilder image. Casson himself considered this one of his most important pictures of the 1930s. He showed it in the first exhibition of the Canadian Group of Painters, of which he was a founding member. For the composition, he combined two different sketches of Ontario small towns.*

In the later watercolour, he returned to the subject to explore the way clouds cut off the light so that it falls only on the background, leaving the foreground in shadow. It's a subtle painting, enhanced by delicate washes.

PLATE 116

A. J. CASSON

Approaching Thunderstorm, c. 1935

Watercolour on paper

43.2 x 52.1 cm (17 x 20½ in)

Private collection, Ancaster

Although the Group can be said to have ended in 1933 with the founding of the Canadian Group of Painters, its influence, and even that of Thomson, continued. This canvas by Holgate reflects his knowledge of their work. The use in the foreground of the shadow of a tree which lies outside the picture was a motif of Jackson's (it appears in his The Edge of the Maple Wood, *Pl. 15) and later of Thomson's. The effect of a lit foreground and background in shadow was a favourite of Harris's, and the holes in the clouds recall Carmichael. However, the plastic treatment of tree and solid snow on the roof of the shack is typical of Holgate.*

PLATE 118

F.H. VARLEY

Night Ferry, Vancouver, 1937

Oil on canvas

81.9 x 102.2 cm (32¼ x 40¼ in)

McMichael Canadian Art Collection, Kleinburg

Purchase, 1983

The composition of Night Ferry, Vancouver *is particularly challenging to the viewer, whose eye is directed to the horizon along the pole of the ferry. In the background, Varley mixed impressions of New York with memories of Vancouver and Seattle. Varley wrote his son John that there was a cut-out moon in the sky, and the flurry of waters behind the boat were like peacock feathers. He continued: "A couple of lovers on the lower deck are influenced by the crazy moon and give me pale rose & dusky gold while a stocky figure with sprawled out legs stolidly stands with his back to the spectator & you have to guess what he thinks." (This "figure" is Varley himself.)*

In a way, the painting is a postscript. In it, Varley seemed to look back over his earlier years of fame and achievement to ponder the uncertain future ahead. It also points to the future direction of the enlarged Group of Seven, known as the Canadian Group of Painters, formed in 1933. The Canadian Group would increasingly explore the urban theme and use new and more experimental ways of dealing with the natural world. It was the first group in Canada dedicated to the modern movement, though what modernism meant changed through the years. At first, under the influence of the founders, painters were concerned with the mood and rhythm of the landscape. In time they came to embrace an architectural sense of form — and abstraction. The father figures remained the Group of Seven, but members found new vitality in opening up the boundaries and forming a new group.

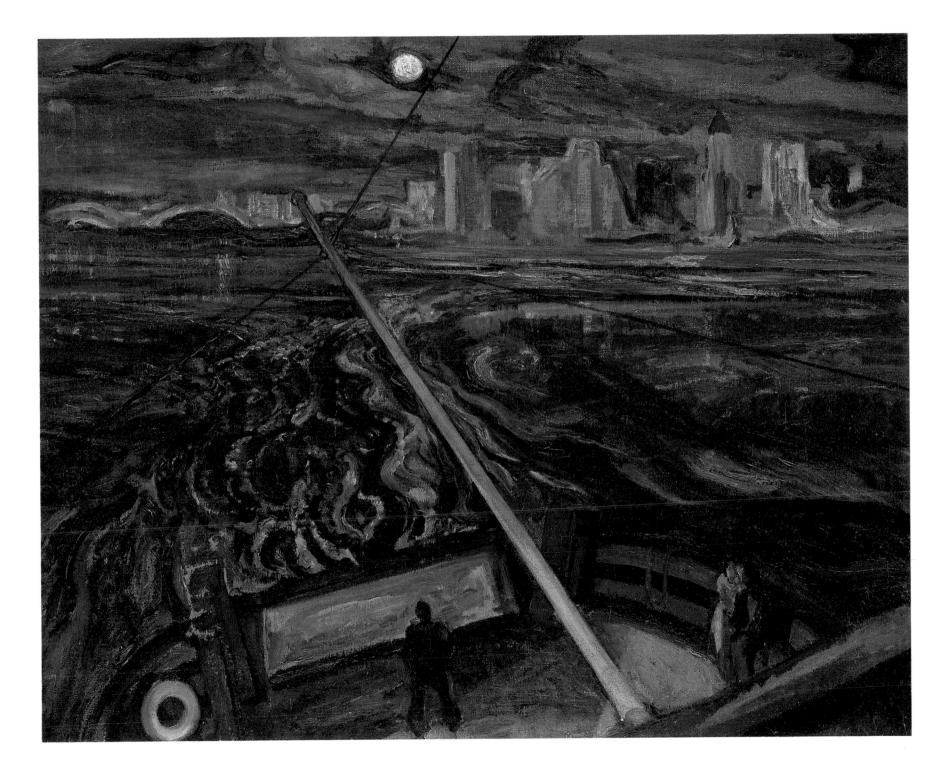

CREDITS

Agnes Etherington Art Centre, Queen's University, Kingston (Larry Ostrom), 31, 147

Art Gallery of Hamilton, 51

Art Gallery of Nova Scotia, Halifax, 17, 23, 57, 83

Art Gallery of Ontario, Toronto (For A.Y. Jackson's *Algoma Rocks*, Carlo Catenazzi), 10, 13, 22, 30, 32, 35, 54, 61, 65, 67, 69, 76, 97, 99, 101, 115, 117, 119, 135, 143, 153, 166, 167, 179

Art Gallery of Windsor, 103, 141

Canadian War Museum, Ottawa (William Kent), 84

Gallery Lambton/Cultural Services, Sarnia, 149

Hart House Collection, University of Toronto (T.E. Moore, Toronto), 60, 105, 121, 132, 133, 170, 187

Ken Thomson, Toronto (T.E. Moore, Toronto), 20, 88, 120, 123, 131, 134, 146, 164, 170

London Regional Art and Historical Museums, 139

Macdonald Stewart Art Centre, University of Guelph, 44, 145

McMichael Canadian Art Collection, Kleinburg, 16, 18, 21, 38, 39, 43, 68, 73, 86, 87, 93, 126, 127, 176, 177, 193

The Montreal Museum of Fine Arts (For J.W. Morrice's *Sainte-Anne-de-Beaupré* and J.E.H. MacDonald's *The Sleighing Party*, Brian Merrett; Tom Thomson's *In the Northland*, Marilyn Aitken), 33, 42, 63, 80

Musée du Québec (Patrick Altman), 15

National Gallery of Canada, Ottawa, 29, 45, 47, 49, 52, 53, 55, 58, 59, 70, 71, 75, 79, 81, 89, 95, 107, 109, 110, 111, 112, 113, 118, 155, 161, 169, 171, 175, 181, 183

The Robert McLaughlin Gallery, Oshawa (T.E. Moore, Toronto), 91, 129, 157, 159, 162, 164, 165, 185

Vancouver Art Gallery (For F. Varley's *Dawn*, Jim Jardin; for Lawren Harris's *First Snow*, and A.Y. Jackson's *Wartz Lake*, Trevor Mills), 72, 104, 137, 173

The Weir Foundation, Queenston, Ontario, 74

Winnipeg Art Gallery (Ernest Mayer), 125